フィリップ・フ

地域社会に密着して

の活動家たちが自ら

の完全

河出

SIGNAL 08

Signal:08 edited by Alec Dunn & Josh MacPhee
© 2023 PM Press — Individual copyright retained by
the respective writers, artists, and designers.

ISBN: 978-1-62963-566-8 (paperback)
ISBN: 978-1-62963-306-0 (ebook)
LCCN: 2022942564

PM Press, PO Box 23912, Oakland, CA 94623
www.pmpress.org

Design: Alec Dunn & Josh MacPhee

Cover image: Production still from *Slave Rebellion
Reenactment*, photo by Soul Brother, © Dread Scott,
2020. Frontispiece: outside image is the cover of
Liberation magazine's August 1961 issue; inside image
is from the 1972 Japanese edition of Philip Foner's *The
Black Panthers Speak*. Background image on this spread
is an image of the 1970 Dawson's Field hijackings by
the Popular Front for the Liberation of Palestine.

Printed in the United States.

Thanks to everyone who worked on this issue. Special
thanks to Mark Davenport, Wade Ostrowski, Joey
Paxton, Carissa Pfeiffer at the Black Mountain
College Museum, Merce Williams, and everyone at
PM Press for their continuing support of this project.

SIGNAL:08

From the beginning of *Signal*, we have maintained an open-handed approach to political art. Our first issue gathered a wide range of strategies: from playgrounds to graffiti to comics to prints. We have continued this tradition by choice and by necessity. We maintain a spreadsheet of subjects we'd like to cover, of writers who might be able to contribute—but this list is slippery and dynamic. Each issue ends up with whatever rolls in from our contributors, and the final table of contents often doesn't have any relation to our original plan. This haphazard and often accidental approach to content has built a complicated pattern, one that offers multiple truths, abundant paths, and generous and generative strategies. We chose the title *Signal* for its obvious metaphorical implication: a signal is something concise and directed, a pointed communication that spurs action, but *signal* is also a verb, an idea in motion.

Some ideas have been static throughout our existence, and here we state them again: We believe that culture plays a crucial role in social transformation and that cultural work not rooted in liberation reinforces the ongoing crisis in which we live. We continue to believe that the writing, studying, and making of political culture should be open to all—especially those involved in said social transformation—not just those credentialized within academia.

SIGNAL
is an idea in motion.

Social media has made it easier than ever to access the political culture of movements worldwide. At the same time, it is a terrible archive, with amazing material everywhere one day and gone the next. It's excellent for sharing techniques but bad at teasing out motivation, context, and thought. When we started *Signal*, we wanted to carve out a space for clear-eyed and in-depth writing about the role and potential of cultural work in political movements, with a focus on sharing imagery, strategies, and aesthetics that challenged any preconceptions of what political art could or should be. Thirteen years later, with eight issues under our belt and millions of images available at the flick of an index finger, we still believe that the questions and challenges of making liberatory cultural work beg for space, thought, and consideration.

We welcome submissions of writing on cultural production for future issues. We are particularly interested in looking at the intersection of art and politics internationally and assessments of how this intersection has functioned at various historical and geographical moments.

Signal can be reached at: signal.editors@gmail.com

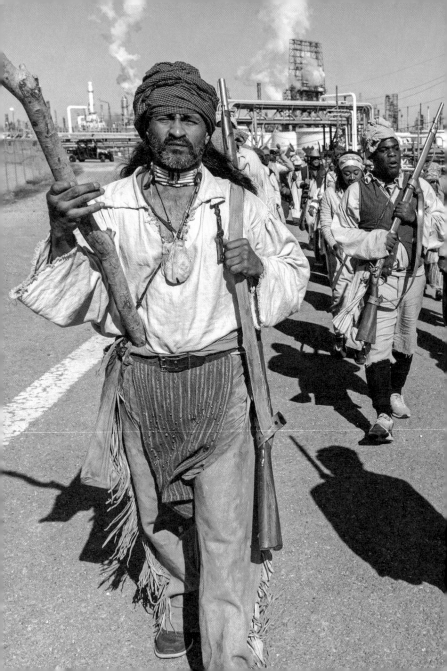

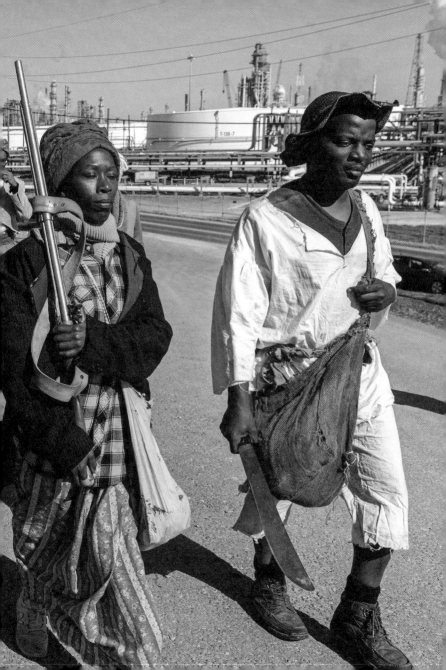

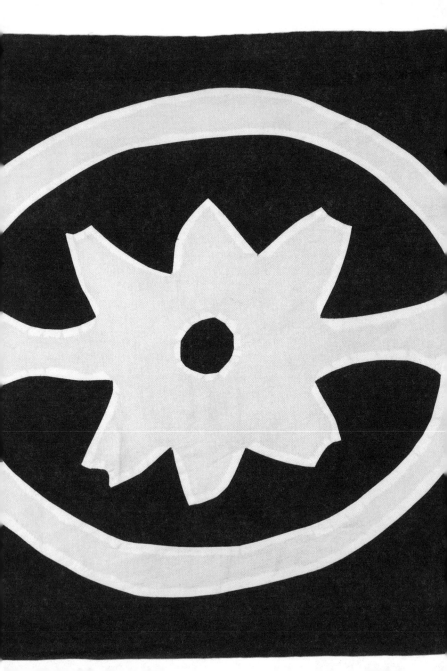

ver two days in November 2019, artist and activist Dread Scott organized hundreds of Black people to reenact the German Coast Uprising of 1811 on its original site, the river parishes outside of New Orleans. Dubbed the *Slave Rebellion Reenactment*, Scott and four hundred other descendants of enslaved people marched twenty-six miles over two days, all in period dress and carrying muskets and other weapons. I spoke to Dread about the *SRR* in May 2021, our far-ranging conversation touching on the social and logistical networks necessary to carry out an action at this scale, the tension between art and life for both participants and viewers of historical reenactments, and much, much more.

—Josh MacPhee

How did this project start?

Most artwork doesn't come quickly for me; it is a long process. But in a weird way *Slave Rebellion* came to me fairly quickly. In 2010, or thereabout, I had an idea: "Oh, you know, I'd like to see a slave rebellion reenactment." It really was only that thought out. And part of how I think is, "Well, what are ways to talk about the world and what doesn't exist?" And I question if something doesn't exist, why doesn't it exist? And then I say, "Well, should it exist?" When I had the idea of a slave rebellion reenactment, I stopped and thought, wait a minute, that actually *is* interesting. I haven't seen one. Why haven't I seen that? Well, oh, yeah. This country is founded on slavery and genocide, and it still needs white supremacy at its core. So that's why I haven't seen one. And should this exist? Yeah, that'd be kind of fun to see. It'd be really cool. So, I got invited in 2013 to go to the McCall Center, which is in Charlotte, North Carolina, and it's an artist's residency, which is project based. And they asked, "Will you tell us what you want to do?" and

I responded, "I think I'd like to do a slave rebellion reenactment." Thinking, there's no way they'll agree to this, especially when I tell them that it's not probably going to happen during the residency, and it's probably not going to happen in Charlotte. And they called my bluff. They said, "Sure."

Oh, damn, now I have to think, what is this? What does it mean? Why am I interested in this anyway? At the time I thought, I'll just do Nat Turner's rebellion, or maybe some amalgamation of Nat Turner and Gabriel Prosser. The residency director coincidentally had just heard somebody talking on NPR about a revolt that had happened in 1811, in New Orleans. And I was like, I don't think you're right about that because I know a fair amount about American history, and particularly about the history of enslavement and rebellions, and I hadn't heard of it. So, I was going to prove her wrong—I did a tiny bit of research, and was like, "Oh, damn! This is true. Okay, I want to check this out."

I got the book by Daniel Rasmussen called *American*

Uprising: The Untold Story of America's Largest Slave Revolt, in which he talks about this guy who's a real expert on this history, who lives in New Orleans. And so, I decided I gotta go meet this guy. I went down to New Orleans and started looking for this guy, Leon Waters. He, as it turns out, had family history with this rebellion. When he was a kid, he had an older cousin who said, "Our ancestors fought against slavery." And, you know, he was ten and he's like, "Wow, that's cool." But then he gets older, and he becomes a revolutionary, and he's talking with some friends. And he was telling them the story. And they said, "Leon, if there's any truth to that, we have to find that out. We got to figure this out." So they became people's historians, and did research and found newspaper articles, documentation of tribunals that had happened, documents from as far away as London. After the rebellion was put down, they found letters between the governor and the general that led the counterattack.

So they unearthed this story of the largest rebellion of enslaved people in US history and in 1995 self-published this book that recounted it, *On to New Orleans!* Once I heard about that, and got into the details, I decided that's the rebellion I want to do, because it had a lot of things going for it: one, it is this hidden and suppressed history that I thought people should know about; two, it was large, and that would enable a reenactment to have a lot of people participating; then three, the participants had this bold vision of not just striking back against slavery, but actually setting up an African republic in the New World, which would have outlawed slavery. And that's really important. You know, Nat Turner wanted to overthrow slavery, but as far as I understand, he didn't have a vision of setting up a separate state, having laws and policy, et cetera. Charles Deslondes and the other leaders of this rebellion seem to have been thinking, based on their connections to Haiti, that, "We want to set up an African republic." And they had a chance of succeeding. You know, all slave revolts are a long shot. But this actually had a chance—it was not doomed from the beginning.

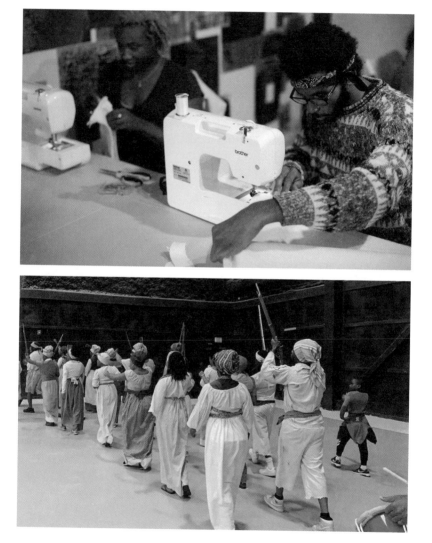

Charles Deslondes had freedom of movement. So, he went from plantation to plantation and recruited people who became his lieutenants. Those people in turn recruited other people, by word of mouth. And that's how the reenactment was basically structured. While we did bring in some internet-based organizing toward the end, and brought on some people that were movie extras, most of the people were built up over the course of years, by word of mouth—people having one-on-one conversations with each other about why this nineteenth-century history of freedom and emancipation mattered to us in the twenty-first century. So, organizing the reenactment really became a vehicle for that conversation to happen in a decentralized way. That was out of the sight of most people. The images of the two-day reenactment are amazing, and the costumes are amazing, and the flags are amazing. But what they don't show is this whole network of people—figuring out how to get free, drawing on this history of people who didn't want to just lessen the horror of slavery, but wanted to overthrow it and made plans to do that, learning from that history and trying to apply it in the present. This happened doing the reenactment, but also became ongoing, with participants becoming ambassadors for freedom going forward. That was the heart of the project.

Starting at the 2013 residency, I spent the next six years building up the network of people to be the reenactors, but also the organizational infrastructure, a large part of which was based out of Antenna, a small multi-arts organization in New Orleans. It became the logistical organizing hub and cultural repository for the project. I'm not from New Orleans, but because they were community based, they could introduce me to the people I needed to meet.

Publicly the project was a reenactment of this rebellion; it had about 350 participants, mostly Black, some Indigenous, in historically accurate period costume marching for twenty-six miles over the course of two days, from LaPlace, which is the town about thirty-five miles upriver from New Orleans where this rebellion initially started, down to Kenner, which is where the New Orleans airport is

located. That's the historic route of the rebellion. At Kenner we interrupted the historic timeline, got on buses, and went into the city of New Orleans itself, and then marched from what's called the Old US Mint to Congo Square. In 1811, the Old US Mint was the site of Fort St. Charles, which the enslaved were trying to seize. They had an advanced detachment who tried to seize that fort, so that people, once they got out of the fields, could get weapons to seize the city. From there we marched to Congo Square, which is a place that's really important for the preservation of African culture in the Americas, specifically rhythm. Enslaved people were allowed to gather on Sundays and have traditional dress and traditional dancing. And so the rhythms that became foundational for jazz, and then blues, rock and roll, hip-hop, bounce, trap, disco, funk—all of it is preserved because of the existence of Congo Square and a couple of places like it in other parts of the country. When we got to Congo Square, we flipped from a military campaign to a celebration and lifted up the names of all the rebels of 1811. And so that, in a relative nutshell, is the rebellion reenactment.

So 350 people? How many of them were involved in this build-up process and these political discussions?

Ultimately, almost all of them. I recruited a core of maybe 25 to 30 people about two years before the reenactment itself. So, looking back in 2017, there were probably about 25 people that were really in the Army of the Enslaved; there were other people working on the project— costume designers or project managers or fundraisers or other people—but the reenactors were about 25. Then about a year out, we had expanded that to about 75 or so. And from that period, it was growing. The most intensive recruitment and organizing happened only about two months out—by this point we had gotten about 250 to 275 people. And then in that last two weeks, we brought on another about 75 people. It was a deliberate method of organizing: I brought on a core

of people who then found the people who they thought should participate through one-on-one clandestine conversations. Because this was a weird project in that it had a very visible presence. I mean, it had a web page, it had an art organization that was doing it, it had public funding, we had a Kickstarter campaign, you know, so there's a very public aspect of it. But how the Army of the Enslaved, which was the backbone and core of this project, got pulled together was sort of clandestine, and I was explicitly telling people, look, we're not organizing this by a Facebook group, we're not organizing this by email, you have to go meet people and have conversations with them. If in 1811, with threats of death and much closer surveillance, enslaved people could organize to get free, then we certainly can. We should also honor that. You know, the internet is a powerful tool and useful for a lot of things. A lot of activism happens there. I'm not a Luddite. But we also don't need to lose or further lose the skill of just fucking talking with people in one-on-one conversations. And that's how it was organized.

That takes time. It's actually part of why the recruitment process was slow. Because I knew that we couldn't get 350 people and hothouse them for three years while I raised funds. We had students at Xavier University, which is a historically black college, and we recruited them maybe about three years out, and then they graduated, and they moved back to wherever they came from. So we realized we can't have the recruitment and funding go together. So there was an intentional slowing down in some cases. But it was also because it's word of mouth, because people have to take the time to meet people and drive out to see somebody or have conversations about whether they want to walk twenty-six miles through some areas, parts of which are Klan country, carrying a musket. And, you know, bringing a prop weapon to a gunfight is not exactly what inspires most people to say, "Oh, yeah, let's do that!" And you know, even walking twenty-six miles is difficult to do for a lot of people who ride in cars all the time. So we had to have walking practice: "Okay, today, we're going to walk a mile, next week we're going to walk two miles, next week

we're gonna walk four miles." It was an intentionally slow process so that people could both develop the conversations and grapple with this history and also develop the strength and organization and costumes and everything necessary to do the reenactment.

The organizing process is profoundly counter to the inherited assumptions about how things should be organized in the twenty-first century. It also implies that the goals were beyond this two-day event.
Yeah.

Have you seen anything that came out of that organizing?
I mean, yes and no. So, a lot of community-engaged artists attempt to build infrastructure into their projects so that they have an ongoing footprint. There are some great projects: Shani Peters and Joseph Cuillier of the Black School, which is a brick-and-mortar thing, you know, and they're building a Black school in New Orleans. And jackie sumell is doing really great prison abolitionist work with the formerly incarcerated, but also people on the outside, to have them connect with people that are in solitary confinement. There are a lot of important projects like these.

But that's not what this was. I knew that I didn't have the capacity. And I, in part, because of that, didn't have the desire to build a permanent infrastructure that would be continued slave rebellion reenactments going forward. I was like, I'm doing this one-off event. And I have confidence that there will be various organizations and networks that come out of this, but I'm not prescribing what those are. I wanted to do a two-day reenactment of this amazing history and have confidence that if interesting people are brought together and steeped in that history, we'll be taken to interesting places. And that has happened in some ways that I know and in many ways that I don't.

A bunch of people came from Oakland, many of whom were connected to Oscar Grant's family, Beatrice X, and Uncle Bobby, but also a couple other people came from Oakland who

didn't necessarily know that other people were going, but then they all found themselves there. A couple of those Oakland people also had ties to New Orleans. I mean, one of them lived there for many years. So she's connected to one of the key drummers from the project. They've formed ongoing groups, we've done reunions, but they've also been really active in the anti–police brutality movement. And it was deeply meaningful for them to participate. They've brought some of the spirit into their whole organizing around police brutality in an interesting way.

Another cool thing is an anecdotal story that got back to me. The movie *Harriet*, about Harriet Tubman, came out a little bit after *SRR* happened. There were some people that had been participants in *SRR* who went to the movie, and they were in one of these theaters that has assigned seating. They go to the theater, they're sitting down, and somebody working there comes up to them and says, "Hey, can I see your tickets?" And, yeah, sure, they show the tickets, that these are the seats they're supposed to be in, and the guy goes away. Then he comes back a little bit later, "Excuse me, you know, I think you're in the wrong seats. Can I see your tickets?" And they're like, "What are you talking about? We just showed you our tickets. But yeah, here are our tickets again." Okay, he goes away, and then comes back a half hour into the film, "We need to see your tickets." And they're like, "No, we need to see a manager." So they went to the manager and said, "Look, this is really unconscionable in a movie about Harriet Tubman that you're harassing Black women. We're part of the Army of the Enslaved and if you don't meet our demands, we're going to come back in with the rest of our army and we're gonna protest at your theater." Then they made a set of demands, including making free screenings available to kids and issuing a formal apology to them. And all their demands were met.

Then there's a lot of stuff that I just don't know about. The project was intentionally decentered in a way. There's no one person who could see or know everything that was happening in the project. I mean, even if you wanted to, even press or photography teams and

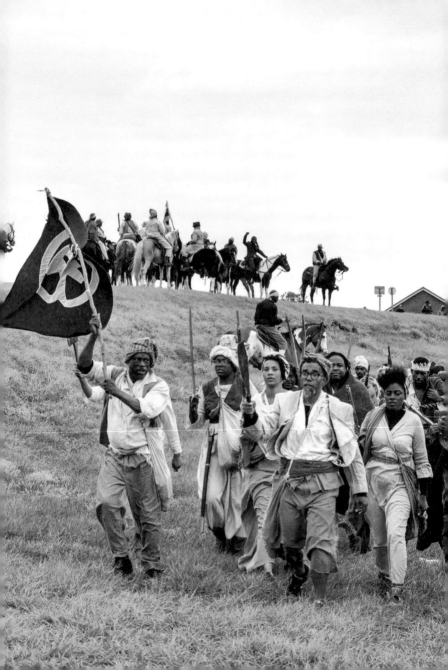

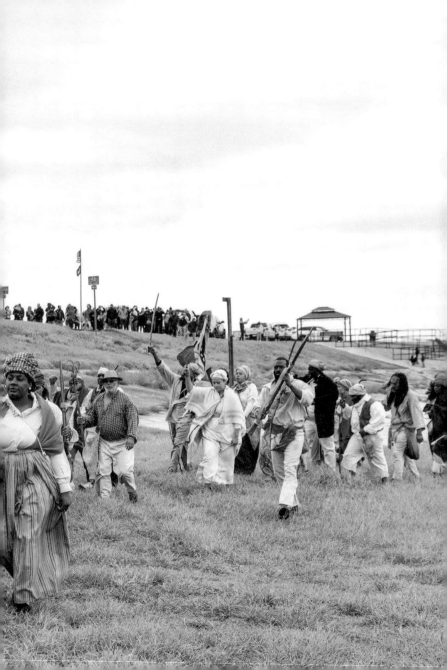

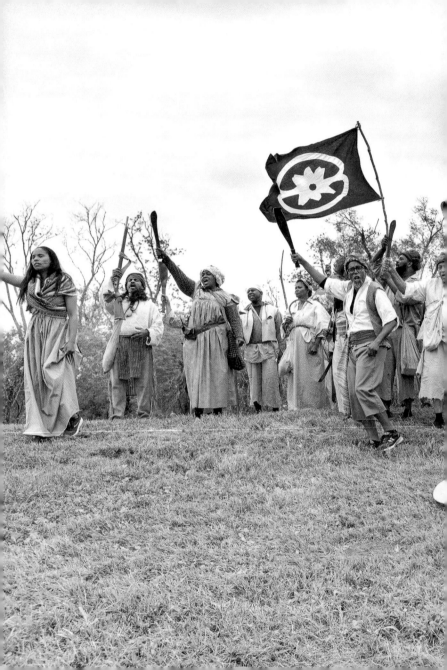

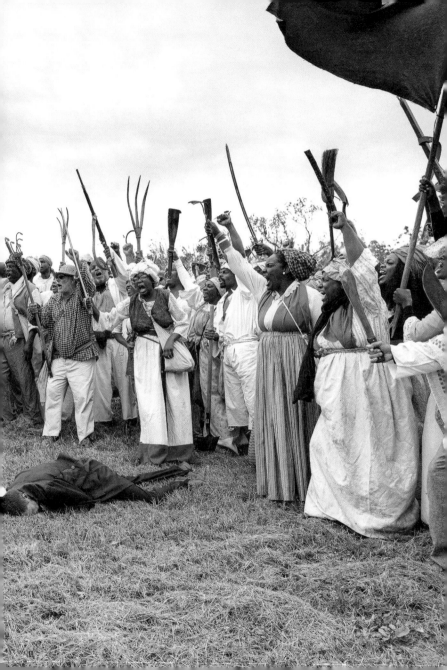

video teams couldn't document everything, because it actually started in two separate places. So you couldn't be in two places at one time. Sure, you could see footage from two places at one time, but you couldn't be in two places at one time. So there's going to be a lot of great stuff that comes afterwards that I'm never going to know about, and I'm just happy if it happens, and when I hear about it that's fantastic. I love it.

We live in a country where a portion of it is obsessed with historical reenactments, particularly of the Civil War. But then there's also a tradition within art contexts of other sorts of reenactments. How do you place the *Slave Rebellion Reenactment* within these other trajectories? Whether it's Civil War reenactments, or something like Jeremy Deller's *Battle of Orgreave*?

Yeah, so I didn't know or think much about reenactments until I decided to do this project. And, you know, the first reference, obviously, was Civil War reenactments, which I knew of, but I hadn't thought much about. One of the first things I did was say, let's go see one. And so I went to the 150th anniversary of the Battle of Gettysburg reenactment, which was weird as fuck. And I mean it! There were ten thousand reenactors. And these were people that are really into history. But it quickly became evident that it was a Southern tradition, that most of the people that were participants thought the Confederates were the good guys, and that if they do the reenactment, just one more time, the good guys are gonna win. They really do love history. And many of them study history a lot, including to get things like the troop movements and the costuming correct. I mean, the detail of the costumes was amazing. And the logistical stuff is not an easy feat. And they're collaboratively organized in a decentralized way. I mean, there are some people who have to get the permits and stuff. But it is driven by the majority of the people that are like, "Okay, I'm with this troop, this is my regiment, this is what I got to do." And it is kind of awesome on a certain level. So I do really appreciate that.

But when you get right down to it, they get the troop movements and costumes right, but they get the key social question of the Civil War wrong. These reenactments, they're reenacting a fiction with the aim of promoting white supremacy. A lot of the Northern guys aren't so steeped in Confederate history, but at the end of the day, they hug it out with these people, many of whom are actually very conscious racists. It is what enabled me to say, what I'm doing is really different. It's not just a difference of scale or costuming, it was about getting the social question of this slave rebellion right.

With my dabbling in some reenactment projects, particularly related to labor history, one of the things I found interesting is when you take a set of social demands "out of time." Even though the demands still exist today, when you dress them up within a framework that appears out of phase with contemporary life, there's something that gets people to engage with them in a way that they aren't willing to do if they're seen in the present. We are familiar with what the demand for Black emancipation within the context of a demonstration against police brutality looks like, and it is sadly easy for many to ignore; in part because it is proscribed, people think they know the boundaries of it. But when this demand is presented by people in early nineteenth-century dress with machetes marching down the road, this is a very different thing.

This was a really Black space, and it was a really free space. When we got to this Old US Mint, it was the freest I have ever felt. And I think that many people who were participating felt so empowered, so strong, that we really were a liberating army in a major metropolitan US city, and we were going to end slavery going forward, not just like, "Hey, we're acting this out," but this was embodying the spirit of freedom and emancipation. It was very real and impactful also for people on the outside. A lot of people said this was the most amazing thing they'd seen. If you have a demonstration that says Black lives matter, fortunately now a lot of people all over the country, including a lot of white folks in places that have no Black people in

them, really do mean Black lives matter. It doesn't mean that racism has gone away or white supremacy is abolished, but it does mean that there's a whole lot of people who are like, yeah, racism is fucked up.

But we felt when they see something like *SRR*, it's a whole different feeling: "Oh, wait, these people are going to free themselves. And maybe I have misunderstood or mislearned history. And maybe I have a role to play in that freedom struggle." There is, I think, an implicit demand to throw out everything you thought about history and incorporate some of what you've just seen.

There was an insightful historian who compared this project to the Civil War reenactments. He said, like with the Civil War reenactment, what it's doing is the audience is being transported back in time to show how it was back then. But with *Slave Rebellion Reenactment*, what's happening is the Army of the Enslaved is being transported in time into the present. Look, there were all these photographers that were trying to

get pictures of people in their nineteenth-century dress but without the oil refinery or without the cars in the background, just in this bucolic setting, but that's not what the project was. The project was about this clash of past and present; it was about all these different slippages.

And I think in *The Battle of Orgreave* or the 1920 Storming the Winter Palace, which was a reenactment of the Russian Revolution in 1917 by many of the same participants, or even some of Mark Tribe's *Port Huron Project*, they all attempt to insert a radical demand into the present in a new way. And I think that with *SRR*, we had one advantage that these other projects don't, that this history is much older, and the temporal displacement is much more jarring because of that. This has bearing on the whole history of how we conceive of this country and how it was formed, with mass incarceration and police brutality. And I don't know that I could have developed it without that groundwork that other people have laid, specifically Deller's *Orgreave*.

But because of the intractability of the problem of white supremacy in US society, and how foundational it is to history and how visible the markers are, because I wear a black skin and that is a defining feature of America that everybody knows, *Slave Rebellion Reenactment* could rupture our sense of politics and race in ways that more traditional activism doesn't always do. You know, sometimes artists have gotten caught up in thinking that the art is the revolution, but I don't think that we're going to throw a bunch of paintings at the system and have them run away. That's not how social change has happened. But it also doesn't happen without a good song or a good community-engaged collaborative performance work.

The reenactment took place in a region that's called Cancer Alley, a petrochemical production corridor on the Mississippi River which was literally built on the footprint of where sugar plantations were. These refineries are highly toxic, with one of the highest incidences of cancer in the country in that corridor. And people have been fighting against that. When COVID struck, they had the highest rate of death from the disease, per capita. They were Black; it was due to preexisting health conditions.

That's actually why the optics of the project worked so well. You're driving to work at NORCO, one of these petroleum companies, or you're hanging out at a bar in LaPlace, or you're going shopping, you're going to get fast food or whatever—and then you see 350 Black folks with machetes and muskets chanting, "On to New Orleans, freedom or death!" You're going to be like, what the fuck am I looking at? I mean, we did a lot of work to let people know what was going to happen there, but even so. With all that outreach, we knew that people wouldn't have deeply engaged with it, they'd be like, "Oh, yeah, this film is happening about slavery." That's probably how most people thought about it. But then you see this and you're like, "What the fuck?!" And then it makes you have to think, "Why would somebody do this? I know something about slavery, but what's this connection to the present, to this land? And how does this relate to this oil refinery that I've been working in that's been killing me and my family?" Our answer was, "Join us."

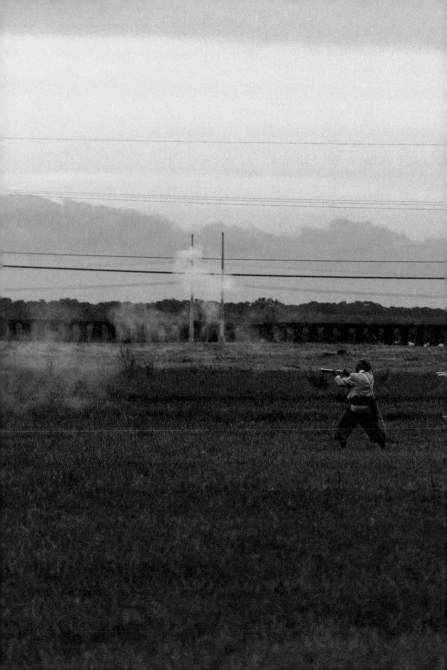

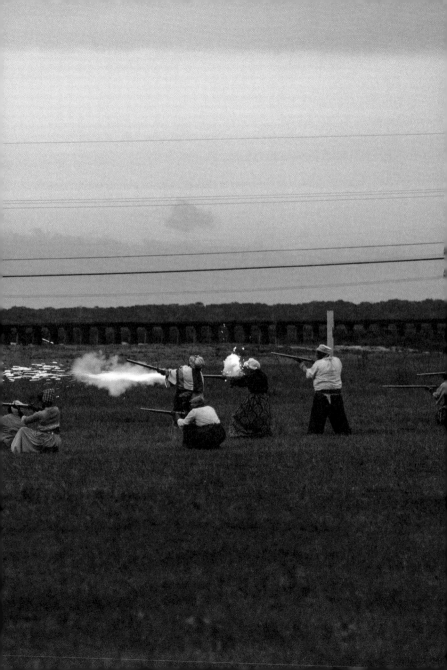

When we did the labor reenactments in Troy, New York, a decade ago, it was all unpermitted, but some of the people that were the most supportive were the cops. They're the most unionized entity in the area, they were like, "Oh, this is actually pretty cool." The Chamber of Commerce tried to shut it all down, and the cops are like, "What do you mean? Why?" Which was totally shocking to us.

The funny thing is the reason we could do *SRR* was because it was historic, and that it would be difficult for white supremacists to say that a slave rebellion didn't happen. It's like, these people were trying to get freedom. Are you against freedom? Oh, no, I'm for freedom. It's not the same as taking down a Confederate statue. That's seen as "changing history." That's something to feel attacked by. But these people are just trying to get free. And so there was a way in which that historic specificity gave us a lot of freedom, and it restricted the freedom of the white supremacists to counter and challenge it.

I'll tell you a funny story. I mean, as you might gather, I'm not a huge fan of cops. And for this project, we had to have a lot of permits. There were *a lot* of permits. We needed a permit from, among others, St. Charles Parish. And so our guy had to go out and have all these meetings with various parish officials, the chair of the parish council, and the various heads of corporations that were in the area. And then a couple days before *SRR*, we had a final meeting where they were going to give or deny us the permit. The Department of Homeland Security was part of it, because we were passing through "critical infrastructure," the oil refineries and such. And so they were all there. So we're sitting with the Shell Oil representative, the head of Destrehan Plantation, which is one of these fucked-up tourist-site plantations that tell a white supremacist version of history—there were like forty people in the room. And there's the sheriff, who is actually the person really calling the shots in the area. They had already said, "Look, you've met the requirements, you're getting the permit," but we had to go through what the

plan was in very specific detail: Okay, this is an area where there could be a huge chlorine gas leak. How are you going to protect your people? Do you have enough buses? Et cetera. So there was an element where they were genuinely looking at our safety plan and not trying to fuck with it.

It was basically a logistics meeting, but they still could have denied the permit. At one point, one of the parish council people gets up and talks to one of the pastors, who was giving us permission to use his church as a place to feed people. She was basically like, "Father, you've got a lot of nerve bringing this to the council at this very last minute. There's not been enough time for us to discuss this," et cetera. "I don't want them wandering through my community." But her husband, who's also on the parish council, was in a meeting weeks before, and he didn't say anything about it then. She's going on, "Well, look, you know, I think we need to, at a minimum, make sure that they can't wander out through the community." And then somebody said, "Well, what are you afraid of?" "Well, they might have a musket. They could harm us." It's basically, I don't want Black people that I don't sanction walking through my community. She's basically trying to get the permit denied and saying that we have not sufficiently asked her permission and could we put a curfew on people, and all this other stuff. And the sheriff—who if you said, "Okay, go to central casting and get me a good old boy," that would be this guy—steps up, and I'm thinking, "Fuck, this is not going to go well." And he says, "Excuse me, these people are American citizens, they have met all the requirements, we are not putting curfews on people, they have the freedom to walk wherever they want, the weapons that you're talking about are not actual weapons, they're prop weapons, so they can carry them. Besides, this is an open-carry state. So even if they were weapons, they could walk around." And it was an interesting moment where he's like, Look, they have constitutional rights. Because of how the project was structured, and because we dotted all our i's and crossed all our t's, it meant that this good-old-boy sheriff could actually put on his Black Lives Matter hat and say, "No, we're doing this."

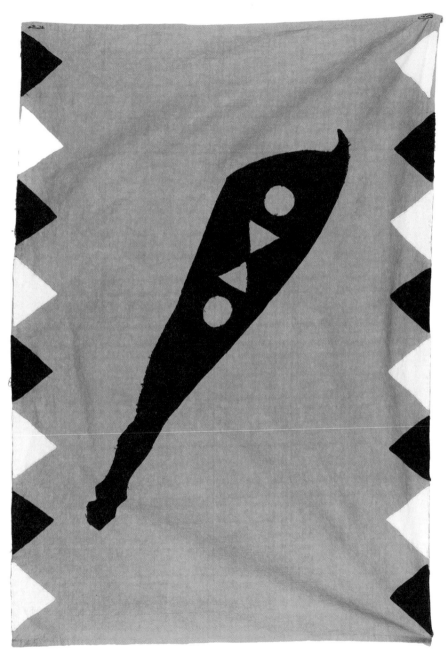

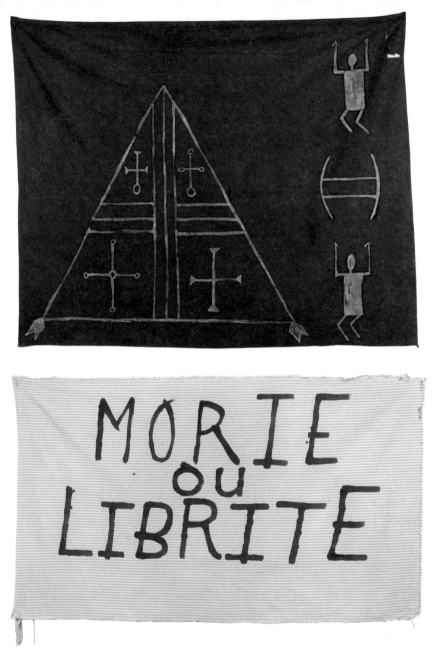

Given the historical distance, that no one who participated actually knows what that original march was like, how much did you script and how much was improvisation?

The route was scripted. The costuming was scripted. There were a couple of moments where we basically had battle scenes where one enslaver was attacked, or another where there's actual musket fire. Those were very tightly scripted, in part for safety. There was still a lot of improvisation, but the scripting was much tighter here. We knew we had to get to the end of the route, and this number of people are doing x, that this number are doing y. But outside of that, it was unscripted. It was people embodying this history; they were given a charge of, basically, playing themselves as part of this history in 1811. Here's the story of what happened and here's the place where we're doing this. Now go.

We did have some rehearsals. Everybody that participated probably had a minimum of two and a half hours of rehearsal where we learned to march as an

Army of the Enslaved. I didn't want people on a Sunday stroll; we actually wanted to embody this thing. We know that in 1811 people marched in formation under flags; we knew that they were organized and disciplined in a certain way. And we wanted the project to exude that. We also had to do some work around security so that we could look militant, but if we got any opposition, we had to be able to de-escalate. So, people did have a bit of rehearsal. This was groups of twenty to forty people at a time, as opposed to the whole group.

I can guess where a lot of the background for the costume design came from, but the other imagery that you used, like on the flags and then in some of the uniform finery—did that come from documentation, or did you just fabricate it based on best guesses as to what things looked like?

Both. The costumes we wanted to be as accurate as we could. Because spontaneously if you ask what enslaved people wore, the answer is usually burlap sacks.

And that's just not true. That narrative ends up further dehumanizing enslaved people. We had two key sources of historical information. One was prints, paintings, and illustrations from the time, but not so much from America because these had already developed into stylized racist caricatures. But if you looked at French colonial stuff from Saint-Domingue, which became Haiti, but also Guadeloupe and Martinique, you saw pictures of men in turbans, and it's like, oh, yes, they're West Africans. It's hot in West Africa. You might wear a turban if you wanted to stay cool. And you saw various colored patterns and prints and stuff like that. It's like, Oh, yeah, the seamstresses and clothing makers were enslaved people, they wouldn't have all been shopping at the local Walmart, they would have been making the shit. And the same people who made it might have come from Senegambia and ended up in San Domingo then ended up in New Orleans. So, the style they're referencing would have been French fashion at the time, even if the clothing is cheap.

The other thing we did, we looked at runaway slave ads. If you believe that you own somebody and they left and you want them back, you for damn sure were going to describe accurately what they wore. And so we looked at these ads that were from the area at the time, and we tried to make clothing based on that.

We knew that they had flags; there was a letter from General Wade Hampton to Governor Claiborne that said there were five hundred brigands marching in formation under flags. So there were multiple flags, but he didn't describe what flags there were. What would they have had? We don't know. So those are all made up, but they're made up based on symbolism that would have been possible for people at the time. There's a flag that says "Death or Liberty." One is a Ghanaian adinkra, which almost certainly would not have been used this way at the time, but it is part of a symbolic language that is used today, Ghanaian clothing with block prints that use these adinkras, the Sankofa bird, or other symbols like that.

And then the symbol is on a blue indigo background. Before sugar was the motor of the economy in New Orleans, indigo was

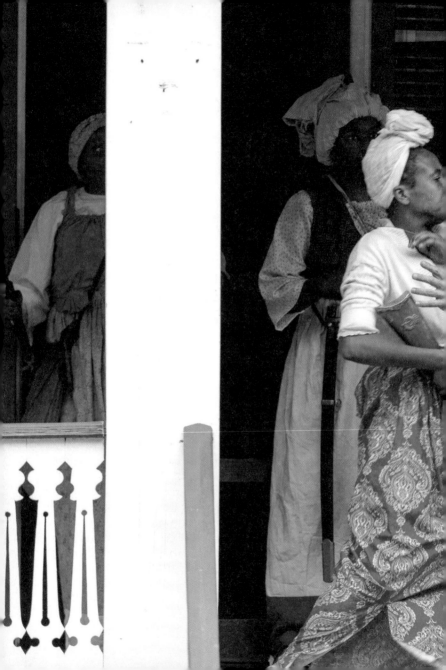

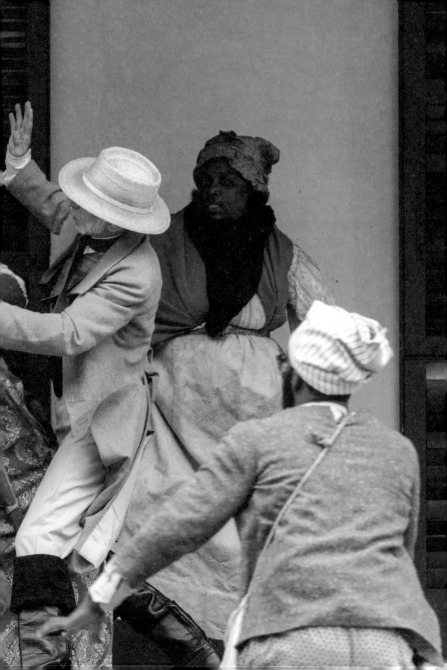

the main crop that was being grown in the region. It eventually changed over to sugar because indigo's not nearly as profitable. But indigo dyeing was a technique that people knew—the skill in cultivation and refinement was brought from West Africa—and it's a beautiful color. So for one of the flags, we used a traditional indigo dyeing and hand-sewn fabric with this adinkra.

I was just reading your site and about *SRR*. It says that part of the goal was opening up space for people to rethink long-held assumptions. But something that's not in that text is, what people and what assumptions?
Yeah, that's true. Well, I mean, there were multiple audiences for this work. As I've discussed, a large part of the audience was the reenactors themselves. And then a more broad audience. In a society that has white supremacy woven into it, there is a Black audience, there's an Indigenous audience, and there's people that are not part of those audiences that are largely white. The assumptions that many Americans, especially those that consider themselves white, have about history, including about slavery, is that enslaved people were not resisting or capable of change. And that's false. It's a white supremacist understanding. One of the insidious things is when that narrative gets into the heads and comes out of the mouths of the oppressed ourselves. And so, you know, there are a lot of Black people who believe a lot of bullshit about slavery. I've discovered a lot talking about this project at universities, including historically Black colleges and universities, and talking with Black students at majority white schools. I would give a lecture that includes one, sometimes two, historians talking about the history of slavery and slave rebellions. Black students would come up to me and say, "Look, we didn't, we didn't want to come to this, we were assigned to come to this. And we didn't want to hear more about slavery. But then when we learned that there were all these instances of slave rebellion that we didn't know about,

that there were over 250 documented incidents of slave revolts in the US with ten or more participants, then we knew that we'd been lied to."

There's a shame of being Black that a lot of Black people have internalized, including a lot of these youth. Maybe the people that have told you this myth of the happy slave or your people being fucked up and just being slaves, maybe that's all a lie. And maybe we actually were fighting for freedom. We're actually the descendants of people who fought back, even if the fighting back was only survival, because surviving enslavement to the point where you can raise children, that's still powerful. Not everybody is going to be Nat Turner or Charles Deslondes; it's unlikely that any of my personal ancestors were either of those people or had direct participation in slave revolts. But clearly they did enough to survive to get to the point where I am here, and that's powerful.

Getting an understanding of this history is also about seeing that how the most radical ideas of freedom and emancipation in the United States in 1811 were in the heads of the enslaved. Not Thomas Jefferson and George Washington. So, if you even want to just talk about democracy and freedom, you should really be studying Charles Deslondes, you should be studying Nat Turner, you should be studying Denmark Vesey. I'm not saying people shouldn't read George Washington. I'm saying, look, let's actually figure it out, let's study who really was identifying this problem. Very few people today would say that owning human beings is consistent with their values of democracy and freedom.

And then getting people to think, wait a minute, the people who were real visionaries were these uneducated people that were working in the fields—those were the ones who had a bold vision of the future that is actually more consistent with my present. And for those of us who are descendants of Africans, it is really liberatory. We're the visionaries. And that has a lot of lessons for how people make change now.

There was a whole crew of people, both a support staff and some lead organizers, that played a tremendous role in making this happen. And I think it's important to acknowledge and say, like Karen Kaia Livers, who was our community outreach person, who then went and talked with people in the River Parishes, I mean, New Orleans is one thing, but where much of this happened is in the River Parishes. She spent day after day after day going knocking on doors, talking with people, meeting with community representatives, arranging meetings for me to have with them to, to work through whether they wanted to participate, how they wanted to participate. There were sewing circles that happened, and these happened all across the country. I mean, there were people in Chicago that made costumes that got sent, because they couldn't come themselves, but they wanted to contribute. One of the key reenactors, this guy Ron Bechet who teaches at Xavier University, enabled us to have meetings on the campus, but also, he made his own costume with his mother. Ron's probably sixty, so his mother's at least eighty or something like that. And she wanted to participate by making his costume. There were all sorts of people like that who really threw in to make this happen. And then there were the people at Antenna and, you know, Bob Snead, who was the director of Antenna, and Jen Crook, who was a project manager and has organized large-scale art events. There were key religious leaders. I mean, Donald August, who's a pastor in a church that's right where the reenactment started and has deep ties to the community that the plantation where the rebellion started, the Woodland plantation, which is also known as the Andry plantation. After slavery ended it, they continued to work people as sharecroppers and so people that grew up in that region have literal memory of their fathers or grandfathers working in the slave-like conditions. It's in LaPlace, which is a little bit out of New Orleans. It's the really poor section, but it is, you could see, literally the map of slavery right there. And so he and

his wife grew up there and really wanted to participate. But they also knew the racism that existed in the area and had to make sure that it was safe for him and people like him to participate, because he said, "Look, Dread, I like this project, I think it's important, but you're going to leave. I'm here. And they firebomb churches in this region. So how can I participate? Why should I take the risk? We have to talk this through. How is this gonna actually be good for my community?"

Another preacher, Reverend Manning, who was based in the city of New Orleans itself, actually met with his people and got them to participate in all sorts of ways. There was this decentralized thing, but there were also these people that really, you know, the project doesn't happen without them. And I don't mean that it wouldn't have been the same, I mean it literally wouldn't have happened. We had some really good conversations about why it mattered, and then they ran with it. And I think it's important to not just be this artist who comes in, has this idea, finds the people, and then does it. Yes, I'm the lead artist. Yes, it was my idea. Yes, the funding happened, in large part, because of me. But this was taken up by aspects of the community in beautiful ways that were outside of my control. I think there's a lot that people can gain from this model. It's not easy, and it wasn't guaranteed, and we got some luck because we met the right people at the right time. This project wouldn't have happened if I didn't have my hand on the tiller a lot, but it also had a lot of high-level, enthusiastic, ongoing, substantive, richly engaged participation by lots of people. I want to make sure that that's encompassed in how the story is told.

You've talked about the very real potential of danger that could come from this. But was there also a flip side of that coin, that by having the SRR be kind of out of time, it allowed for people to engage with the radical at a level that they maybe would have been much more hesitant to be involved in if it was couched in a twenty-first-century framing?

Dude, we brought an armed group of Black people into the city and we lived to tell the story. And people really felt strong because of that. Particularly women. There was a group of about twenty of us who

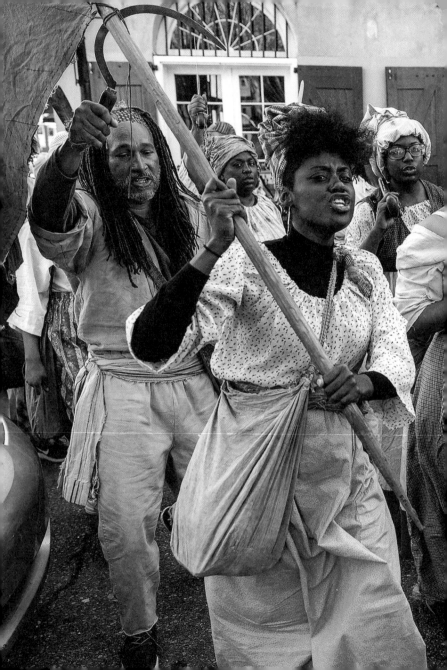

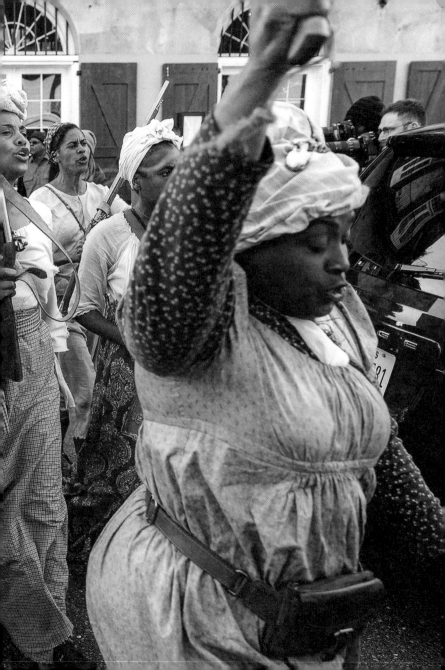

got trained to fire muskets and other black powder guns, some long guns, some short guns. And because they're dangerous—I mean, even if you don't have any shot in them, they're still causing an explosion in a metal tube, and a lot can go wrong with that. Having an opportunity for the women to learn to shoot, even if it wasn't an actual gun and an actual target, was very liberatory. A costume is not complete until you have a machete or a musket or a sickle in your hand. And that made it really real for people.

Some were like, "Look, I've had guns and knives pointed at me, and they've caused a lot of harm in my family or my community." And they were very hesitant. There was this one woman who was like, "Look, I just can't hold a weapon. I can't do that." And so I said, "But you've got to, it's a part of this." "No, I can't do that." So we compromised, and the peace that she made was these little scissors that she hung on a necklace she wore. All right, that's cool. But by the end of the two days, she was carrying a machete! That doesn't solve all of the questions of how people

get free, what those machetes get used for in the future, what the connection between that and any real struggle for power is. A whole bunch of questions that don't get solved with things like, "Oh, we got weapons," in this case machetes and prop antique muskets. But for people who've been kept down by various forms of violence, being able to think through how political violence might be emancipatory, might have been emancipatory, and how it could potentially be, that's important. That it should not be something that is written out of the equation was really important for this project.

Reenacting a slave rebellion is done differently than, say, reenacting a speech from the '60s or a petition campaign or even a march on Washington—it actually poses the question, "Are these people who took up arms worthy of emulation?" You know, there's always a celebration of the march on the Edmund Pettus Bridge that's really great. But this actually posed that the only way these people could get free was overthrowing

the system of enslavement. And there are not a lot of people that would argue that that is true. They might argue that it's not either worth it or possible or that it didn't succeed. But there'll be very few people who could look at history and say, "Well, you could have just passed a law, you could have just petitioned the government, you know, maybe we could get slavery reduced to the point where it's not so bad if you just lobby with a super PAC." Nobody. I mean, it's an absurd proposition.

And so, most people would say, yeah, that's the only way they could have gotten free. What are the implications of that? So if you wanted to end slavery in the United States, it took a civil war. Let's put that into the political thinking of people, let's remove the barrier that outlaws that thinking, as well as limits what political change can happen. There's both the personal, and how you feel about your access to being able to use any sort of violence, but there's also this broader political question of how does change happen? And how might it happen in the future?

I think you're even being generous to most people's reading of history, and history itself in a way. Up until John Brown, almost all white abolitionists fundamentally didn't believe that enslaved people would play a role in their own emancipation. Even people like Frederick Douglass had to be convinced of that.
Yeah.

Even in its moment, most people didn't recognize that slave rebellion was necessary. And I'm not so convinced that a lot of contemporary presentations of that history don't continue the same sort of insidious sidelining of enslaved people's own autonomy of action.
I think you're right. I think it's important to point out that Frederick Douglass, who was a badass radical and a real abolitionist, didn't necessarily conceive of how millions of enslaved people could have really participated in their own emancipation. And yet, when the Fugitive Slave Act was passed, he basically said something to the

effect that it was going to be a dead letter, we will kill people trying to enforce it. I mean, he was not exactly a pacifist.

No, no.
You know, I think he looked at the overwhelming military power of the United States, including in the South, and concluded that with that, as well as the effects of white supremacy in the thinking of enslaved people, it would be very difficult to change things through violence. Only by uniting progressive people into an abolitionist movement could they somehow shift the terms of thinking, through moral suasion.

All social systems seem permanent until they're not. And, look, there are a lot of really good radical people now, including in Black Lives Matter, that think that basically we can lessen racism but we can't eliminate it. Or we can lessen the horrors of capitalism but we can't get rid of it, that it's permanent and that the world that we've inherited has always been here. And that's just actually not true. **Ⓢ**

Photo Credits:
Performance stills (pages 6–7, 18–21, 26–27, 34–35, 40–41) by Soul Brother, © Dread Scott 2020.

Reenactment flags (8–9, 30–31, 46–47) courtesy of Dread Scott.

Production photos (12, 45) by Dread Scott.

Negres de St. Domingue se battantau bâton, Haiti, 1796, from the collection of the Bibliothèque National de France (45).

Costume drawing (45) by Alison Parker/ricRACK and Monica Grist-Weiner.

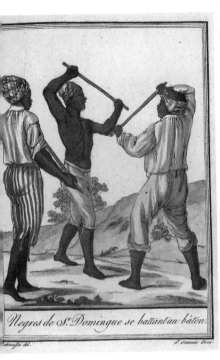

Negres de St. Domingue se battant au bâton.

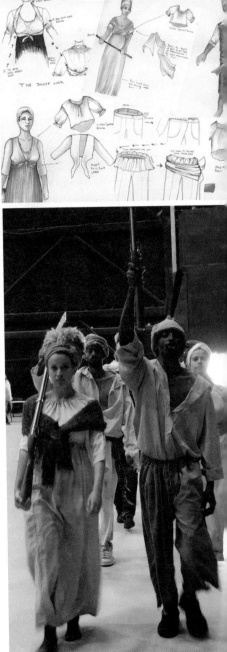

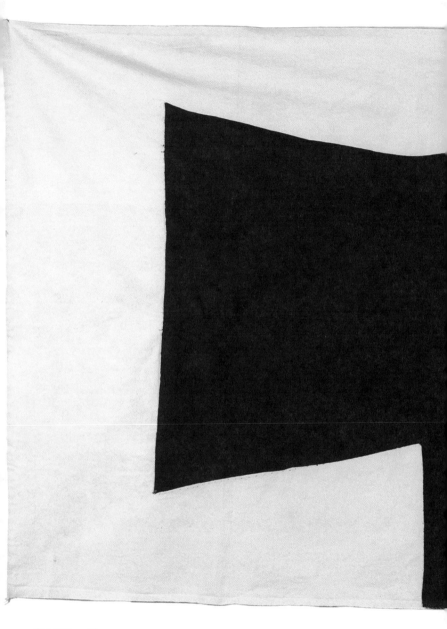

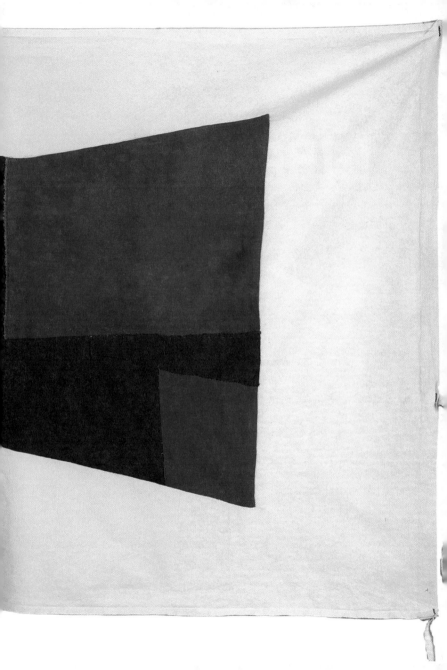

JUNE 1958

LIBERATION

HOPE IN THE MIDST OF APATHY

LIBERATION MAGAZINE
AND THE COVER ART OF
VERA WILLIAMS

ALEC DUNN

I n 2009, *Signal* was still in its conceptual stage. Josh MacPhee and I had yet to publish an issue, and we only had vague aspirations about the contents and the physical size of this journal. At the time we were taking short research trips and casting wide nets, trying to see what was out there and what stuck. In the summer of 2009, we visited a semiprivate archive that doubled as a barn attached to a vacation house in the mountains of Northern California, five miles from any town, with an amazing and exhaustive collection of international anarchist material. A friend dropped us off along with enough supplies for the weekend: food, cameras, a scanner, and a couple of laptops. Josh and I set up in different corners of the barn and did the tedious and joyful work of archiving: digging through boxes, flipping through books, documenting, and scanning.

"Look at this," Josh said at one point, and I poked my head up from the scanner to see him holding up a large, old magazine with a woodcut masthead and an abstract cover. "Hmmm, cool," I mumbled, and turned back to work. We repeated this exact exchange a few times until I finally got up from my ad hoc work station and we both started unpacking a box containing many issues of this magazine, called *Liberation*. At first glance, *Liberation*

contained a surprising blend of modern anarchist thought and firsthand civil rights reporting and theory. The magazine dated from the 1950s—a period when the anarchist movement was widely considered dead (or at least deeply comatose) and when the civil rights movement was gaining steam. And it was surprising to me because, at the time, I knew of no connections between the civil rights movement and anarchist organizing. But what was most surprising, surrounded by 150 years of radical cultural publications and books, was the look of *Liberation*. We were immediately struck by the vibrancy and, honestly, occasional oddity of its cover designs. They were bright things, eye-catching, and showed small variations due to being hand printed. The covers showed a thoughtfulness and intellectual playfulness that was unusual for left-wing periodicals of that era (or this era, for that matter). And then sometimes the covers wandered off into unbridled abstraction: no bounding box, no listed contents, no obvious

political message, just a dense pattern of color and light with the masthead and a date. We took pictures of the magazine and added it to a growing list of items to follow up on.

During a meeting in 2015, now with four issues of *Signal* under our belt, we again talked about tracking down more information about the magazine. Josh had some contacts who mentioned the name of Vera Williams as a War Resisters League activist who was also the primary cover artist for the first decade of *Liberation*, the years with the best covers. I agreed to follow up, and while digging around online a short while later, I sadly found a very recent obituary.

It is impossible, then, to discuss the covers of *Liberation* with Vera Williams and elucidate her process and approach. I am lucky that her life is well documented in other arenas and that I am able to put enough pieces and fragments together to construct a narrative and context for her involvement with the magazine. In the process of doing this, I was continually astonished

with the depth and complexity of her life—her involvement with art and with "Art," with anarchism, pacifism, communalism, protest, and literature. I was also taken aback by the ways these seemingly disparate fields evolved, overlapped, and interweaved in McCarthy-era America. In a 2008 interview, oral historian Connie Bostic said to her, "You've had quite a life," to which the then eighty-one-year-old Vera Williams laughingly responded, "I'm still having it!"

This article is about *Liberation*, a leftist magazine founded in the mid-1950s, and also about one of its primary cover artists, Vera Williams. It seems strange to point out what something is not, but in this case, it is important to note that *Liberation* was part of the radical noncommunist left. The Communist Party USA, with its strong base in American labor, was the dominant left movement in this country in the mid-twentieth century. But its suffocating culture of conformity, its top-down organization, and its dubious Cold War machinations stifled growth and spontaneity. Subsequently, right-wing attacks on rooting out American communism decimated the traditional labor-based American left. In one sense, what remained after these inquisitions were elements of the movement considered to be too far outside of mainstream white-supremacist power structures to be of consequence: pacifists, civil rights activists, anarchists, and artists. (This is not to say that these movements were not victims of state repression or paramilitary violence, which they certainly were. For more on this era, see Andrew Cornell's *Unruly Equality: U.S. Anarchism in the 20th Century*.) You couldn't really blacklist these people, because there was nothing to blacklist them from—they had never been allowed to occupy any positions of power! One of the unintended consequences of the destruction of American communism is that it opened up a space for more liberatory and experimental movements to grow and develop.

Liberation was built out of alliances made between civil rights organizers and pacifist conscientious objectors to World War II. It was physically printed by commune-living activists, weirdos, artists, and homosexuals in a highly conformist 1950s America. Because of

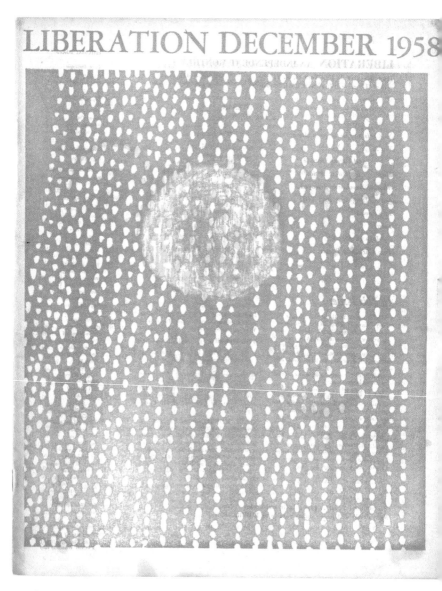

LIBERATION

FEBRUARY 1965 50c

THE CIVIL-RIGHTS MOVEMENT AND THE AMERICAN ESTABLISHMENT • A. J. MUSTE
REVOLT AT BERKELEY • SOL STERN **WORLD TOUR • KAY BOYLE**

these convergent streams, *Liberation* was uniquely positioned in this uncertain and fearful era to explore new practices and strategies in the struggles for freedom, peace, and justice.

Vera Williams (née Baker) was born in 1927 and grew up during the Great Depression in New York City. Williams was the daughter of working-class Jewish radicals, a red-diaper baby. As a child, she recalled attending protests, standing on street corners with a tin can to raise money for Republican Spain, and going to antieviction and rehousing actions with her parents. She had a natural affinity toward art that was nurtured by her parents, and she attended free Federal Art Project classes for youth in the Bronx during the New Deal.

Upon graduating from high school in 1945, Vera Williams enrolled in an arts program at Black Mountain College in North Carolina. Black Mountain was an experimental college founded in 1933 by left-wing educators in an attempt to create a holistic learning environment that blended arts training, humanities education, democratic decision-making, and physical labor. It attracted many well-known artists and experimentalists as both faculty and students, including M.C. Richards, John Cage, Ben Shahn, Buckminster Fuller, Jacob Lawrence, and, importantly for Vera Williams, Josef and Anni Albers—faculty members of the German Bauhaus who fled Germany after the seizure of power by National Socialists in 1933. (The Bauhaus had been under increasing pressure from the ruling Nazi Party, with many faculty members labeled as degenerate artists, and permanently closed in 1933. Anni Albers was under double threat as a Jew. The Alberses were invited to teach at Black Mountain at its inception in 1933.) Williams loved the rural environment of Black Mountain; for a teenager from New York City, farm life to her was both alien and romantic. She also thrived in the experimental curriculum of the school and innately fell into the rhythm of discipline, labor, and play that was encouraged there. In the interview with Black Mountain historian Connie Bostic,

LIBERATION

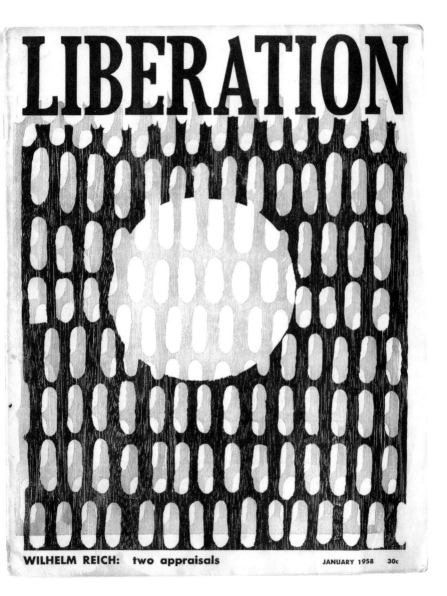

WILHELM REICH: *two appraisals*

JANUARY 1958 30c

Williams credits the rigorous direction of Josef Albers, who was her primary instructor and graduate advisor, as a primary influence:

> I was eager to do everything when I got there. I took weaving with Anni Albers. Thread and string drives me crazy, but I loved the interaction and the colors. I took drawing and painting and design and color, all four subjects that Josef Albers taught. He cared about the visual aspect of everything, to the extent that you might say it was an aesthetic autocracy, what color could be painted, what lettering could be used on the college . . . you know from the Bauhaus there was this attention to every aspect of modernism—even like the tableware, everything was thought about—that art applies to every area of life.
>
> There was no one who taught printing at the time, but a few of the students revived this abandoned print shop. We activated the presses, and then after the war we got a new press from the government. My graduation project was in the graphic arts. As a child I had painted very colorfully. I loved color, but I became very drawn to black and white, to the expressionists and to woodcuts, which was possible to do there with our small means. So as part of my project, I designed programs and menus used by the college. There was an entertainment committee that made decorations, and I invented signage for different events. I did a lot of that. It was just wonderful the way things were connected there.
>
> [My job at Black Mountain was that I worked in the] morning in the milk room. I loved it. I lifted those heavy cans, learned to make butter and cheese, and lived on heavy cream—which was an ambition from childhood! During vacation we had too much milk. We didn't have a contract to sell it, so I don't know how I got this idea—I had sent for publications from the government about milk and making cheese, and I found out you could make paint from milk, so

we made milk paint and painted the whole huge dining room with it. It was milk, whiting, lime, and something to keep it from turning sour and smelling nasty. It was a pretty runny kind of paint, kind of a whitewash. Here I was nineteen or something, a kid from the city, but I just did this, and they let you! They let you do things and make mistakes.

There were people who came to Black Mountain summer sessions who influenced me greatly: Merce Cunningham, John Cage, Katie Litz, who came to do dancing. I liked the theater very much. I did a little puppet show that I invented, in which I was the puppet. You could put your imagination into practice. It was very childlike in that way. The imagination that children have, if you let them pursue it, the playfulness, that was very much there, in the middle of a lot of serious struggles. While I was there, a group, including Bayard Rustin and Jim Peck, people who were badly beaten over the struggle to integrate interstate transportation, came and talked about what they were doing and stayed overnight. There were two farmers there who were pacifists, and this was their alternative service during the war. All of that was going on at the same time as this work of play and imagination.

I came from a very political background, in which it was assumed in my life, as a child, that you were interested in what went on in the world. That you were responsible, that things didn't just happen to you, that you participated in change. We were enthusiastic activists. That carried over very much into life at Black Mountain College.

While at Black Mountain, she met a fellow student and young architect by the name of Paul Williams, whom she married in 1949. Vera Williams graduated the same year, and the couple stayed on at Black Mountain (where Paul had become resident architect) until 1953, when they left the increasingly fractious and unstable institution. Paul and Vera Williams, along with other Black

Mountain alumni and faculty, began searching for a new place to continue experiments in creative collectivity. In 1953, they purchased a 116-acre piece of land about thirty miles north of New York City in the Hudson Valley. It was dubbed the Gatehill Cooperative. The goal was to make an intentional community with an emphasis on creating space for artists, craftspeople, and musicians. Paul Williams designed Gatehill as a small, dense village. The austere and boxy buildings showed his aesthetic debt to the Bauhaus (particularly the architect Walter Gropius, who had taught summer sessions at Black Mountain), while the overall layout of the community, thoughtfully built around squares and workshops, was a practical example of the anarchistic rural/urban design theorized in Paul and Percival Goodman's 1947 book *Communitas*. In her interview with Connie Bostic, Vera Williams emphasizes Paul Goodman's influence on the design of Gatehill:

> He was highly argumentative, a polarizing person, but full of ideas! Very interesting ideas about how we could have an urban and country life, how we could be a community. He talked about things like how the chairs were arranged in a meeting and what it meant. It just made you think about where should the houses be, how should they face each other, what does that mean in how people will talk to each other and so on. Paul Goodman was on the advisory board for our school, which we later started—a very disorderly elementary school where many wonderful things went on. Both Black Mountain and Gatehill Cooperative were more educational than you could bear sometimes! But because they were so open and honest in a way, you were subject to a lot of struggle with self, with other people, with philosophies, and things that didn't work. And that was part of your education.

Vera Williams in her garden at the Gatehill Cooperative (circa 1959). Photographer unknown. Courtesy of the Vera B. Williams Trust. Digital reproduction courtesy of Mark Davenport/Landkidzink Image Collection.

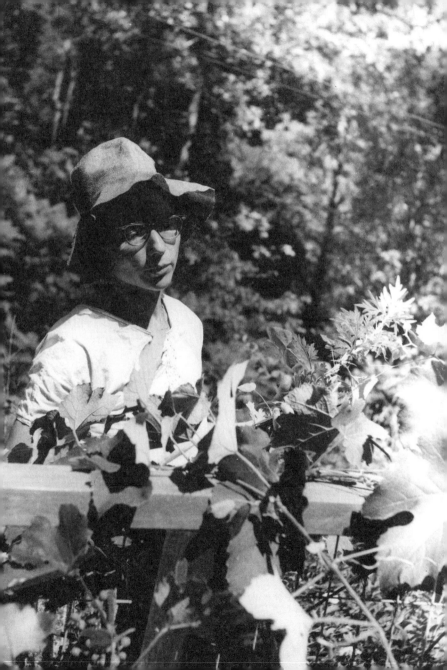

Gatehill Cooperative carried on the interdisciplinary approach of Black Mountain, with the idea that creating artwork, cultivating land, living collectively, and rearing children could, and should, be interconnected. As well as Paul and Vera Williams, permanent residents of the Gatehill Cooperative included composer John Cage, dancer Merce Cunningham, experimental filmmaker Stan VanDerBeek, and potters M.C. Richards and Karen Karnes (among many others), and it functioned as an important node for Judith Malina and Julian Beck of the Living Theatre. Frequent visitors were a who's who of modern art luminaries, including such notables as Karlheinz Stockhausen, Jasper Johns, Richard Lippold, and Robert Rauschenberg.

While living there, Vera Williams became a regular contributor of artwork to *Resistance*, a postwar anarcho-pacifist periodical that was physically printed by David Dellinger and Igal Roodenko at the Glen Gardner Cooperative Community, a Christian pacifist commune sixty miles away in New Jersey.

Meanwhile, A.J. Muste, a former pastor and labor activist, gathered a small group of radical pacifists to work on a new magazine with the intention to bring focus to revolutionary nonviolence, movement building, and civil rights. The founding editorial board, consisting of Muste, Sidney Lens, David Dellinger, Roy Finch, and Bayard Rustin, had roots in faith-based pacifism and was deeply involved in several resurgent left-wing movements. With funding assistance provided by the War Resisters League, *Liberation* magazine was founded as a bimonthly publication in 1956. Vera Williams, with her connections to the anarcho-pacifist *Resistance* group, started producing interior artwork for *Liberation* from the first issue:

> *Liberation* was printed in Glen Gardner, New Jersey, where Dave Dellinger lived, and they were trying to have a communal life there too. We were close to them and I used to go down there a lot. The first cover I did was for an article

 uary 1963 40c

LIBERATION

ort from India:
IA, CHINA, AND THE GANDHIANS
J. Muste

COMMUNITY OF SCHOLARS
C. Richards and David T. Wieck

OREAU: THE ADMIRABLE RADICAL
ighton Lynd

ert I. Young ⋆ Albert Bigelow

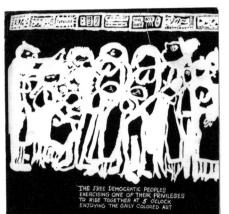

THE FREE DEMOCRATIC PEOPLES
EXERCISING ONE OF THEIR PRIVILEGES
TO RIDE TOGETHER AT 5 O'CLOCK
ENJOYING THE GAILY COLORED ART

LIBERATION
SEPTEMBER 1958 PRICE .30

arch 1962 40c

LIBERATION

THE ARTIST'S STRUGGLE FOR INTEGRITY James Baldwin

SCHOOL SEGREGATION IN MANHATTAN Paul Goodman

CUBA AND THE COLD WAR Leslie Dewart

THE OXFORD CONFERENCE OF PEACE GROUPS A. J. Muste

EARLE REYNOLDS & EVERYMAN III Barbara Deming

Special Reports: Kentucky Miners' Strike ⋆ New Peace Walks
Pacifists Confront Cuban Exiles ⋆ Another N. Y. C. Teacher Fired

JUNE 1959 30c

LIBERATION

THE TIMES REPLIES TO OUR ACCUSATIONS
A SECRET ARMY FOR NATO
REXROTH AND LIPTON ON THE SOCIAL LIE

that Paul Goodman wrote about Wilhelm Reich. I was interested in that, so he asked me to do the cover. The next one I remember doing is when a little group sailed a sailboat into the Pacific to try to bollocks up the nuclear weapons test that was about to be held. They had a much larger printing press there, and I was able to be very experimental about the covers. I did woodcuts, I did drawings. I had a lot of freedom about what to do. And when the war in Vietnam was underway, I had been a longtime activist against the war, against nuclear weapons, and I was able to express that on the magazine.

The table of contents of the first issue of *Liberation* typifies the tone of the magazine for the next decade. It contains an article by Vinoba Bhave about land redistribution in India, while John Dickinson wrote about guilt in postwar Germany, Pitirim Sorokin about peace policy and hypocrisy, and Kenneth Patchen published poems and experimental pieces. Bayard Rustin was slotted for an article about the civil rights protests in Montgomery, Alabama, but missed the deadline. (The article was pushed to issue no. 2.)

The second issue of *Liberation* featured a cover article about the Montgomery bus boycott by Martin Luther King Jr., as well as the previously mentioned article by Bayard Rustin, and *Liberation* became an early platform for firsthand discussion and coverage of the civil rights movement. It was the first publication to print "Letter from Birmingham Jail," Martin Luther King Jr.'s defense of direct action and civil disobedience in the face of racism, and it also included an early debate about revolutionary Black self-defense between Martin Luther King Jr. ("The Social Organization of Nonviolence," October 1959) and Robert F. Williams ("Can Negroes Afford to Be Pacifists?," September 1959). *Liberation* continued to be internationalist in orientation, with frequent articles about struggles in Cuba, Europe, Africa, and India. It drew on both its religious and modernist roots to publish

Liberation

April 1959 30c

THE KING
EMBROIDERING
IN
JAIL

OR
THE UNIVERSITY
AND THE CORPORATION
Bernard Rosenberg

BEYOND THE LABOR PARTY Colin Ward C. WRIGHT MILLS & THE INTELLECTUALS 2 POEMS BY ALLEN GINSBERG

articles focused on the political inner life, nature and the natural world, and the alienation of humanity under modern capitalism. Regular contributors included Paul Goodman, Dorothy Day, Staughton Lynd, James Baldwin, Kenneth Patchen, and Kenneth Rexroth. *Liberation*'s basis in anarchism, particularly an ascendant strain of anarchism that was less based in labor struggles and more

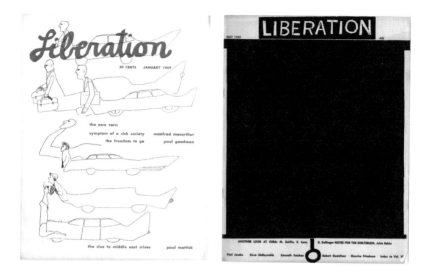

concerned with prefigurative politics and lifestyle, was plainly stated in an early editorial titled "Hope in the Midst of Fear" (January 1958):

> It is *Liberation*'s conviction that the personalist, libertarian point of view is the authentically practical and humane philosophy toward which many people are groping today. Great revolutions are made by ordinary men to die—and live—for a dream of brotherhood. Such moral readiness is nurtured by the example we set each other in the everyday contacts of life. The grassroots revolution must start in the traditionally neglected areas of daily life where we live, eat, work, communicate, and raise children. It is here that men develop the capacity for happiness, for sharing, and for resistance to the evils that beset our age. At home and on the job, as well as in world affairs, we must learn to say NO to those who would control and plan our lives for us. Similarly we must refuse to be part of a "revolutionary elite" which seeks to impose the good life on others. Let us begin to put our revolutionary ideals into practice. Let us invite others

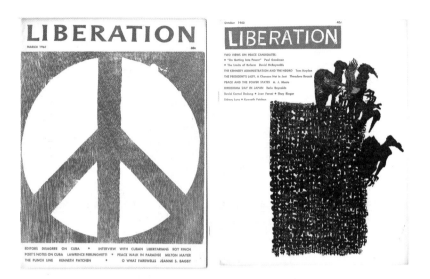

to join us in libertarian schools, non-authoritarian family relationships, and in decentralized, communal workshops.

Liberation's printing press was located at the pacifist Glen Gardner commune, with the actual printing of the publication done by David Dellinger; Dellinger's wife, activist Elizabeth Peterson; and Igal Roodenko (who, along with *Liberation* editor Bayard Rustin, participated in the first Freedom Ride, *The Journey of Reconciliation*, in 1947, for which both Roodenko and Rustin were arrested and sentenced to time on chain gangs in North Carolina). The first ten years of Liberation show smart, if not overly ambitious, interior design—minimalistic page layouts and cool typesetting often accompanied by expressionistic brush illustrations. But the covers are another story entirely. Other leftist magazines used art and artists to enliven their covers, but *Liberation* had almost wholly divested itself from having cover artwork informed by the social(ist) realism common to artists of the left. Furthermore, no other magazine on the left had given over the cover so completely to such a creative spirit. Vera Williams, with her first cover in 1958, became the primary cover artist for the

LIBERATION

OCTOBER 1960

30c

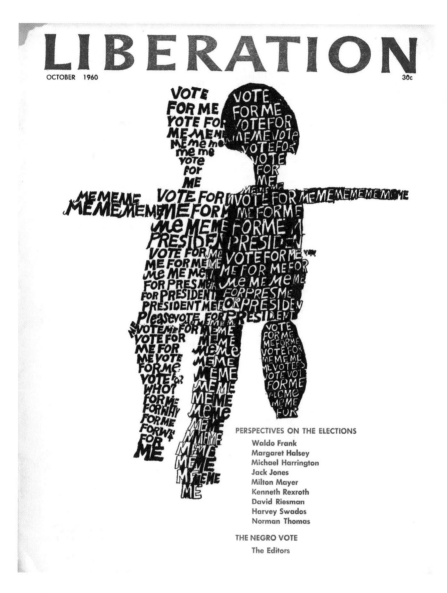

PERSPECTIVES ON THE ELECTIONS

Waldo Frank
Margaret Halsey
Michael Harrington
Jack Jones
Milton Mayer
Kenneth Rexroth
David Riesman
Harvey Swados
Norman Thomas

THE NEGRO VOTE

The Editors

LIBERATION

MAY 1959 30c

LIBERATION

MAY 1960

30c

CIVIL DEFENSE DRILL A NATIONAL EXERCISE IN MIND SHELTERING HELD EVERY SPRING
[COMPULSORY IN N.Y. STATE]

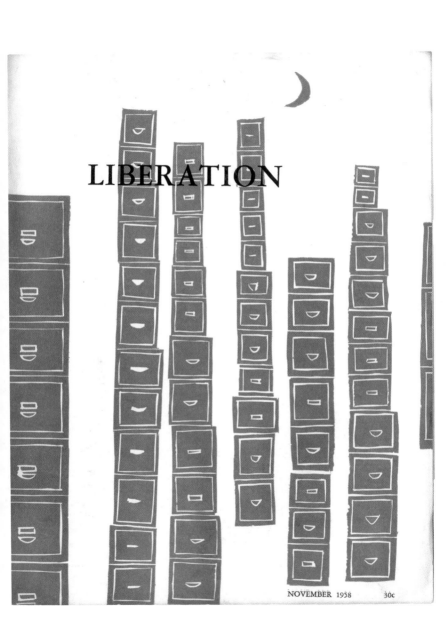

LIBERATION

40¢

September 1962

LIBERATION

next decade of the magazine (and continued to produce interior illustrations as well).

he covers for *Liberation* evince a set of political beliefs that affirm life and struggle. They celebrate nature, children, women's work, education, peace, and equality and criticize or satirize capitalism, racism, war, and imperialism. In general, Williams's early covers are existential commentaries on modern life, the middle period covers look increasingly toward civil rights, and the later covers, as the war in Vietnam accelerates, tend to focus on images relating to Vietnam or to the peace movement.

I will attempt to contextualize some of Williams's *Liberation* covers as best as I can. One impressive element is that she moves effortlessly between many styles and approaches to cover design. I recognize a spirit of collectivity in her work, one in which she purposefully shows influences and draws connections. And in researching some of her positions on education, art, and living, I

believe it is safe to say that she considered the artist to be neither alone and cut off from the course of life, nor the central thinker in her own political discourse, but part of a greater movement.

Williams's early covers place her squarely in the school of European-influenced modern American artists. Her more cartoony covers show a debt to the German expressionists' pointy and violently sharp lines and geometry. Her work is typically figurative, with some sense of realism or social import, but she also finds ways to play with abstraction, pattern, and color. The alienation of life under modern capitalism, as well as Williams's roots and continued proximity to New York City, reveal themselves in several of her early covers. The drudgery of urban commuting is shown on the September 1958 issue, with the irony-laden text "The free democratic peoples exercising one of their privileges to ride together at 5 o'clock enjoying the gaily colored artwork" under an image of a densely crowded subway car with one set of tired eyes staring at the advertising. A cover from a couple of months later shows stacks of file cabinets resembling skyscrapers or religious spires, with a small crescent moon hovering above them. On the January 1959 cover, we see automobile-businessman cyborgs, the fins of the cars looking predatory, for an article titled "The New Cars: Symptom of a Sick Society." May 1959 shows a new take on the capitalist pyramid, also a premonition of Ronald Reagan's trickle-down economics, with business and the military on top throwing cash in the air as a dwindling supply of bills reaches the lowest level—a woman and child holding the whole affair up but receiving almost nothing. A later cover from February 1965 revisits these themes, showing workers forced to ride underground, surrounded by advertisements and exhortations, while a rocket is offered the freedom to fly into space.

Her first cover concerning civil rights appears in October 1958, with an abstracted Black face and white face, the white face looking slightly menacing and unyielding to accompany an article about school desegregation for the feature "Report from

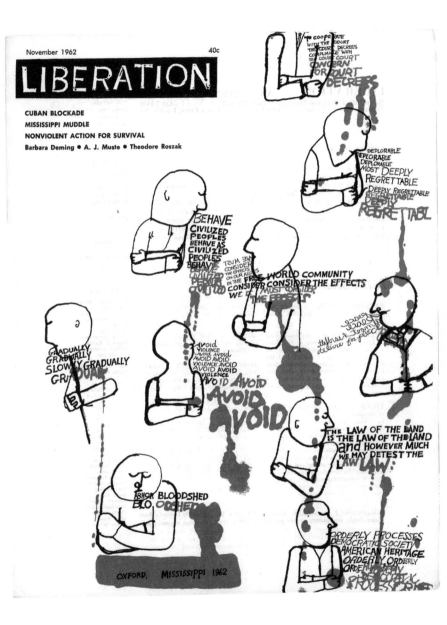

November 1962 40c

LIBERATION

CUBAN BLOCKADE
MISSISSIPPI MUDDLE
NONVIOLENT ACTION FOR SURVIVAL
Barbara Deming ● A. J. Muste ● Theodore Roszak

TO COOPERATE WITH THE COURT THE COURT DECREES COMPLIANCE WITH THE COURT COURT CONCERN FOR COURT DECREES

DEPLORABLE DEPLORABLE DEPLORABLE MOST DEEPLY REGRETTABLE DEEPLY REGRETTABLE REGRETTABLE DEEPLY REGRETTABLE

BEHAVE CIVILIZED PEOPLES BEHAVE AS CIVILIZED PEOPLES BEHAVE CIVILIZED PEOPLES COULD

WE MUST CONSIDER THE EFFECTS ON OUR ALLIES IN THE FREE WORLD COMMUNITY CONSIDER THE EFFECTS WE MUST CONSIDER THE EFFECTS

GRADUALLY GRADUALLY SLOWLY GRADUALLY GRADUAL

AVOID VIOLENCE AVOID AVOID AVOID VIOLENCE AVOID AVOID AVOID VIOLENCE AVOID AVOID AVOID

THE LAW OF THE LAND IS THE LAW OF THE LAND and HOWEVER MUCH WE MAY DETEST THE LAW LAW

ABHOR BLOODSHED BLOODSHED

ORDERLY PROCESSES DEMOCRATIC SOCIETY AMERICAN HERITAGE ORDERLY ORDERLY ORDERLY DEMOCRATIC PROCESS ORDER

OXFORD, MISSISSIPPI 1962

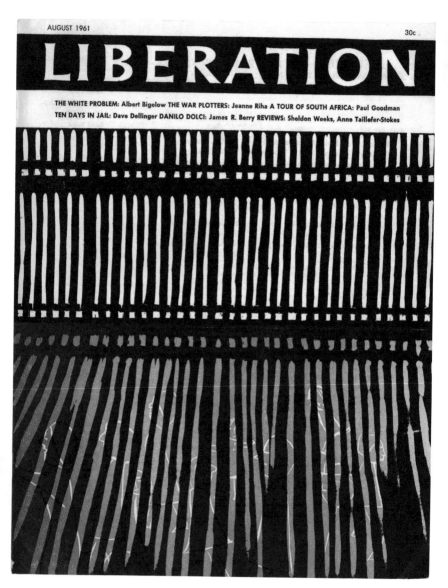

AUGUST 1961

30c

LIBERATION

THE WHITE PROBLEM: Albert Bigelow **THE WAR PLOTTERS:** Jeanne Riha **A TOUR OF SOUTH AFRICA:** Paul Goodman
TEN DAYS IN JAIL: Dave Dellinger **DANILO DOLCI:** James R. Berry **REVIEWS:** Sheldon Weeks, Anne Taillefer-Stokes

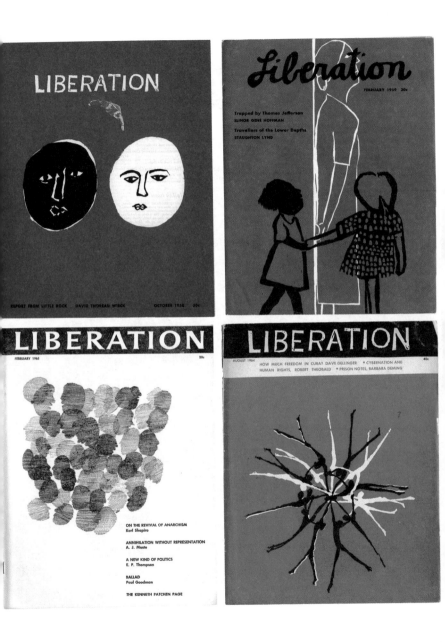

Summer 1963

40c

LIBERATION

THE NEGROES OF BIRMINGHAM Barbara Deming & Dave Dellinger ● **TOWARDS A QUAKER VIEW OF SEX** ● **PEACE STRATEGY** A. J. Muste, Homer Jack, Dagmar Wilson & Jeanne S. Bagby ● Hans Haselbarth Christian Bay Jesse Gordon Gene Hoffman Cleveland Moffett Paul Goodman Muriel Rukeyser R. H. Horn

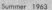

OCTOBER 1963 40c

LIBERATION

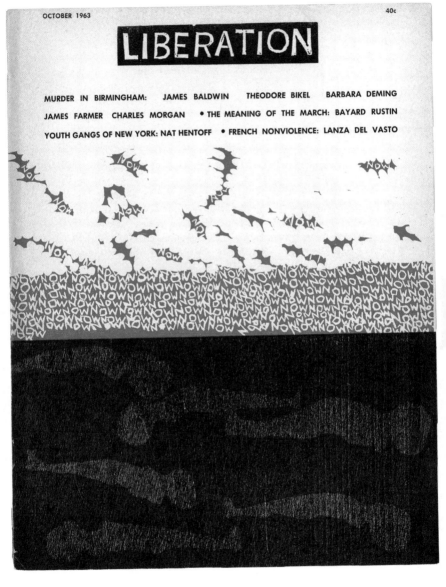

Little Rock." Similarly, we see a Black child and a white child on the cover of the February 1959 issue, holding hands and staring at an exhausted-looking woman. Black and white faces in semiabstracted silhouette make up the cover of February 1961 in a more nuanced image about race, acknowledging a variety of complex relationships. On the August 1961 cover, Williams composed an arresting image of the civil rights struggle, a mass of people moving together through the summer shadows of a fence. The image looks like a protest, but with the vertical shadows of the fence in the foreground, it carries the menace of imprisonment and repression. In November 1962, we see a more pointed cover that illustrates the violence of white liberal gradualism, for an accompanying article about desegregation and the subsequent riots and murders at the University of Mississippi. The Summer issue from 1963 is the first cover about civil rights that really centers Black Americans in the struggle, by showing a large, predominantly Black crowd confronting the future with the word "NOW" woven into the mass of bodies. And there is a continuation of this on the cover of the October 1963 issue, which shows a similar crowd, now breaking off into the air—fragile like birds, or growing like fire, rising up from the blood and bodies of martyrs underground. This arresting image accompanies an article by James Baldwin about the bombing of the 16th Street Baptist Church in Birmingham, Alabama. August of 1964 is another picture of interracial relations, showing spinning Black and white bodies holding on to an unstable center, holding on to one another (mostly, but not exclusively, whites holding whites and Blacks holding Blacks).

Several covers celebrate the beauty of the natural world. They don't tie in with the subject matter of the magazine but most likely reflect Williams's and the publisher's rural communal life and interests in naturalism. A particularly lovely cover during the autumn of 1959 shows a face and eyes looking upward with wonder as leaves fall to the earth

LIBERATION

NOVEMBER 1959

30c

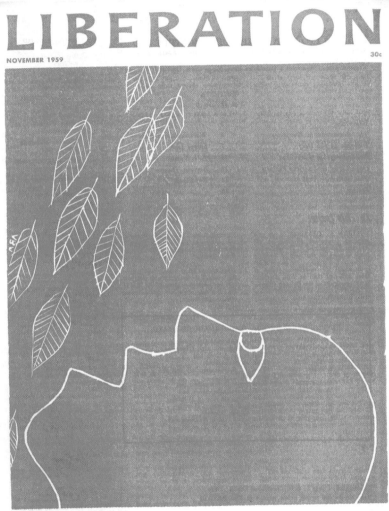

THE REVOLUTION IN WEAPONRY
DIALOGUE OF THE DEAF

William C. Davidon
Sidney Lens

LIBERATION

APRIL 1961 30c

DESIGNING PACIFIST FILMS, PAUL GOODMAN "A NUCLEAR MISHAP," AN A.E.C. REPORT

THE CUBAN REVOLUTION: DAVE DELLINGER, CARLETON BEALS, & A LETTER FROM HAVANA

The Promise of Spring
after a long long winter?

LIBERATION

SUMMER 1959 50c

THE TOTALITARIAN MIND ROY FINCH JOSEPH STAROBIN JACK JONES
THE PROTEST AT OMAHA MISSILE BASE

LIBERATION

MARCH 1960 30c

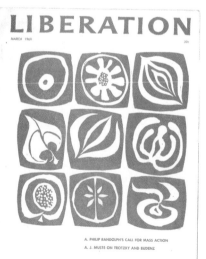

A. PHILIP RANDOLPH'S CALL FOR MASS ACTION

A. J. MUSTE ON TROTZKY AND BUDENZ

SEPTEMBER 1960 30c

LIBERATION

CONVERSATIONS WITH A CONGOLESE CONGRESSMAN ANN MORRISSETT

THE AMERICAN LEFT AND INTERNATIONAL POLICY MULFORD Q. SIBLEY

THE POLITICS OF THE LEFT EMILE CAPOUYA

A MATTER OF FREEDOM JUANITA NELSON

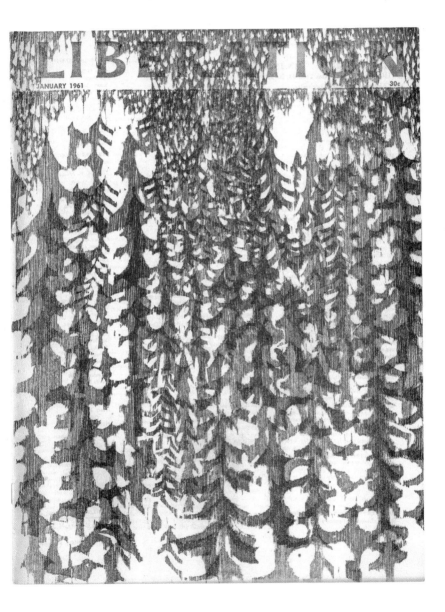

LIBERATION

DECEMBER 1965 50c

THE PROTEST AGAINST THE WAR IN VIETNAM: DEATH BY BURNING
STUDENT CAMPAIGN AGAINST THE DRAFT ● IS THE U.S. WILLING
TO NEGOTIATE? ● ● BERKELEY: WHY THE STUDENTS REVOLT
STAUGHTON LYND • SIDNEY LENS • PAUL BOOTH • DAVE DELLINGER
PAUL GOODMAN • JOHN GERASSI • A. J. MUSTE • HELEN MEARS

LIBE

APRIL 1966 50c

LIBERATION

APRIL 1965 50c

A Policy for the Far East: An Exchange
Between George F. Kennan & A. J. Muste

LIBERATION

STAUGHTON LYND REPORTS FROM NORTH VIETNAM 75c
February 1966

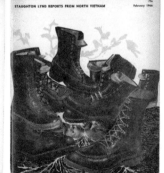

LIBERATION

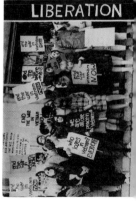

LIBERATION

JANUARY 1966 75c

STOP THE WAR IN VIETNAM NOW!

MARCH ON WASHINGTON ● BERKELEY VIETNAM COMMITTEE

ALLEN GINSBERG ● PAUL GOODMAN ● A. J. MUSTE ● BARBARA DEMING
STAUGHTON LYND ● SIDNEY LENS ● DAVE DELLINGER ● CARL OGLESBY

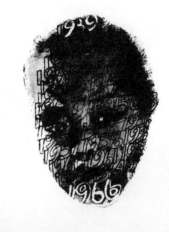

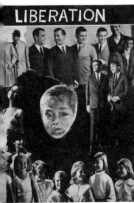

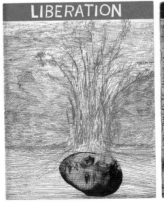

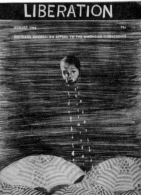

on a solid orange background. March 1960 is illustrated with a verdant harvest print of leaves and cut fruit. September 1960 is a dense and complex field of wildflowers and weeds. There are also a handful of beautiful abstract covers that play with pattern and tone, involving experiments with printing and color overlays (January 1958, December 1958, January 1961) that feel influenced by her schooling in weaving, pattern, and color.

Williams's 1960s covers increasingly focus on the war in Vietnam and are informed by her lifelong antimilitarism. In May 1960, she depicts the threat of nuclear annihilation, showing a compulsory civil defense drill of people voluntarily falling en masse in the face of an atomic war, this normalized facet of American life depicted as both farce and nightmare. A beautifully simple drawing adorns the cover from April 1963, showing a small voice, a lone new mother's plea for peace, as something elemental rising up through the earth, through her body, and out into the world.

For her last year of covers, from 1965 through most of 1966, Williams placed the face of a Vietnamese girl on multiple issues. In a magazine with many unconventional covers, this is one of the more experimental choices, a running motif on successive issues—symbolic of the accelerating war, ever-present to the American public though sometimes in the background, sometimes in the foreground. In Williams's work, the girl's face stands as a symbol for Vietnam itself and appears for the first time, on its own, surrounded by a field of white in April 1965. She is haunting and moonlike over a nighttime American cityscape later that year, in December 1965. She appears again in February 1966, crushed under American combat boots, and in January 1966 scribbled with the years of colonization and occupation of Vietnam across her face. In August 1966, she is crying tears of rain on oblivious American flag umbrellas. In a later issue, the same face is dead in the ground but supporting new life. She appears again in trees like

April 1963 40c

LIBERATION

new leaves in April 1966 and then as the sun in the Summer 1966 issue. We find her face again in the midst of a repurposed fashion advertisement, and then she makes her final appearance among a group of American children protesting the war in March 1966.

The editorial board of *Liberation* underwent successive changes in the late 1960s, and Williams's last cover was in 1966. The hardening of the New Left and the rise of the counterculture codified *Liberation*'s covers into a more directly political, but also more staid, approach. *Liberation* stopped publishing in 1977, a remarkable twenty-one-year run.

Vera Williams remained active in antiwar and liberatory educational movements. As mentioned above, while at Gatehill she helped start and run an experimental elementary school, modeled after A.S. Neill's emancipatory Summerhill School in England. In 1970, newly divorced, Williams left Gatehill Cooperative and moved to Canada. At first, she worked in an experimental school in Ontario, and later she moved to Vancouver, British Columbia, where, in 1975, she began writing and illustrating books for children, the body of work for which she is now most celebrated. Her children's books often tell stories about young working-class girls. They emphasize boldness, generosity, color, and imagination. *A Chair for My Mother*, her most well-known book, tells a story of neighborhood solidarity as a young family recovers from a house fire.

She moved back to the US in 1979. While building a successful career in children's literature, she continued her activism in the peace movement:

> [In 1981] I took part in a group called Women's Pentagon Action to grieve and resist the amount of money and attention that was and is now, more than even then, being poured into war. We blocked the steps of the Pentagon, we wove them

shut with ribbon [laughs], and the police cut the ribbons, so we threw more ribbons up. It was meant to be expressive of female interests. The author Grace Paley wrote a wonderful statement; she took the ideas of everybody and fashioned them into something called the unity statement. A lot of us learned it by heart, and we sat on the steps and chanted it, and many of us got arrested. I ended up going back to the South in chains, in a bus, to the federal prison in Alderson, West Virginia, where I stayed for a month. So I had a new educational experience. I don't want to make light of it, of what it would've felt like if I knew I would have to be there for years. But for a month it was remarkably enlightening, because unless you get sent to prison you don't know about it, and you still don't really know about if you're there as a white middle-class woman with lawyers and with the press eye on you, you know? But you do get more of an idea about it.

Williams was involved in the War Resisters League for most of her life; she sat on the executive committee from 1982 to 1988 and organized and illustrated several calendars for the organization. In 1993 she collaborated with Grace Paley on the book *Long Walks and Intimate Talks*, which consisted of Williams's illustrations and Paley's words. She died in her home in New York State in 2015 at the age of eighty-eight. Vera Williams authored fifteen books for children and received several awards for her work in children's literature.

Liberation's use of cover art was not all that different from other midcentury magazines of the left, such as *Dissent* (more socialist) or *Masses and Mainstream* (more communist). *Dissent* had an arty masthead, but art was an afterthought—secondary to the ideas and views presented. *Masses and Mainstream* had more polished and conventional cover art, but the art was set into a consistent layout, a typographic box, and was firmly in the school of social realism. With *Liberation*, the art was unbounded, not with the feeling that

art itself is the place of liberation and freedom, but that art, creativity, experimentation, and curiosity are part of the collective movement toward liberation. The inclusion of Vera Williams as an almost exclusive cover artist gave this woman a unique platform that reflected the best elements of the midcentury anarchist movement—experimental, questioning, intersectional, and relevant. **S**

Sources:

Bostic, Connie. "Vera Baker Williams Oral History." Produced by Black Mountain College Museum + Arts Center, October 3, 2008. Video, 44:05. https://www.blackmountaincollege.org/volume6/vera-baker-williams-interview.

Cornell, Andrew. *Unruly Equality: U.S. Anarchism in the 20th Century.* Oakland: University of California Press, 2016.

Molesworth, Helen. *Leap Before You Look: Black Mountain College 1933–1957.* New Haven, CT: Yale University Press, 2015.

Sutton, Gloria. "Communitas ... After Black Mountain College." *bauhaus imaginista*, edition 4: Still Undead. https://www.bauhaus-imaginista.org/editions/8/still-undead.

Williams, Merce, and Mark Davenport. Email message to author, 2022.

Grace Paley and Vera Williams in front of a Greenwich Village bookstore promotional display of the War Resisters League 1989 Peace Calendar, "365 Reasons Not to Have Another War," which Grace wrote and Vera illustrated, December 1988. Photo by Ed Hedemann.

PUBLISHING AND DESIGNING BLACK POWER BOOKS

ANDREW FEARNLEY

I n 1967, when Chairman Mao's *Little Red Book* was published, it sold a hundred thousand copies in West Germany, sixty thousand in France, and at least forty thousand in Italy. The text was widely embraced by activist organizations across Europe, and it became a staple of US Black radical groups. "Many Panther chapters use Mao's red book as a text," Dan Georgakas wrote in 1969 in *Quaderni piacentini*, the Italian New Left periodical. Georgakas, a Detroit-born poet and labor historian, had spent time in Rome, and he came to serve as a frequent source of information about US protest movements among Italian radicals. He advised on *Black Power/Potere Negro: Analisi e testimonianze* (1967) by the sociologist Roberto Giammanco, his friend and former exchange student to the US. The opportunities for transatlantic travel that Georgakas and Giammanco experienced encouraged international collaboration—and this proved one of the distinctive qualities about the movements of the late 1960s and early 1970s. Books were a strand of activism, one of the key ways that nascent liberation movements exchanged ideas and strategies, and protest was advanced through print.

Books by and about global figures of revolution, including Mao, Frantz Fanon, Fidel Castro, Ernesto "Che" Guevara, and Malcolm X, were a signature feature of leftist radicalism in the decade after the mid-1960s. Translated into many tongues, sold cheaply as pocket-sized paperbacks, and produced by an assortment of institutions—from large publishing houses to left-wing presses to experimental grassroots organizations—they were one coil in the global circuitry of opposition.

Among the movements for which books became a crucial component of their public identity

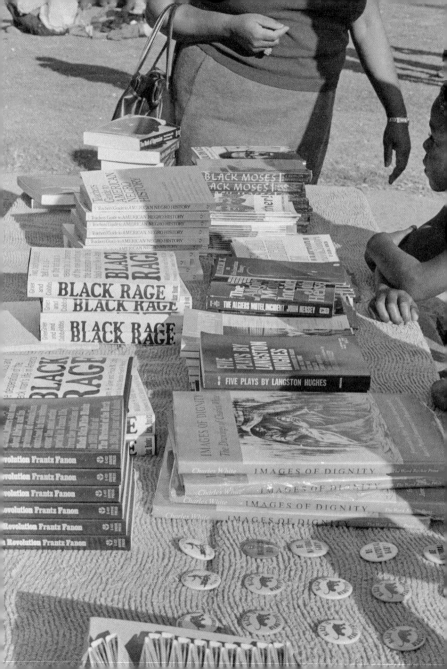

Giammanco

Black Power

Potere Negro

Editori Laterza

and program were those written by, for, and about US Black Power activists and organizations. By the early 1970s, books by this movement's leading exponents, including Kwame Ture (then known as Stokely Carmichael), Eldridge Cleaver, and Jamil Abdullah al-Amin (then known as H. Rap Brown), had won huge popularity in the US and far beyond. The same was true of accounts written by prominent organizations and political prisoners, such as Angela Davis and George Jackson.

Alongside posters, handbills, and buttons, books were one of Black Power's most important material artifacts. For some readers, they were examples of what historian Quinn Slobodian has called "badge books," public markers of a person's political identity. Sold at rallies, around campuses, at concerts, and in myriad stores, these books also managed to reach a diverse and dispersed audience, and cover design proved crucial in engaging such a varied readership. Publishers borrowed and adapted visual techniques and symbols from America's revolutionary milieu, and the styling of these books ultimately played an important role in shaping popular ideas about Black Power's iconography and program.

PROTEST BECOMES SALEABLE

The "literature of revolution," as one US commentator described it, was part of a larger trend by which protest became saleable in the years around the mid-1960s. The textual dimension of these movements indicates how the world-making convulsions of these years sat atop three interconnected shifts in the structure of Western society: the coming of age of those born at the end of the Second World War; the expansion of higher education and increase in student numbers, particularly, though not only, in the US; and a revolution in global cultural infrastructure. Books marked one conjunction where these strands—leftist politics, radical activism, and media apparatus—fused.

In the US, the crossing of political causes and publishing houses ran deep from the mid-1960s on. As the Harvard literary scholar Louis Menand has argued, "books were bombs" in these years. Such incendiary material included forceful voices demanding action around poverty, feminism, and environmentalism, as well as first-person accounts of countercultural rebellion. The pattern was widespread, though it was most pronounced in the US, where books of revolution sold in huge numbers. Frantz Fanon's *The Wretched of the Earth*, translated to English in 1963, appeared in paperback just as US cities erupted in a "long, hot summer," and 150,000 copies were bought in 1968 as a result, a figure that dwarfs the 3,000 copies that were sold in France in the twenty years after the work's original publication in 1961. Fanon's text, like Mao's, had a seismic influence on American Black Power groups, and sales of the text there evidenced what the *New York Times* called a "[B]lack publication explosion."

The production of books in fact became a conspicuous feature of US Black Power. Works by and about Black political and cultural figures became immediate bestsellers in the US from the mid-1960s on, and within a few years were sold in translations across Western Europe and Japan. Half a million paperback copies of *The Autobiography of Malcolm X* (1965) were bought in the US in 1968, and more than six million copies sold worldwide over the next decade. Within a year of the publication of Eldridge Cleaver's *Soul on Ice* (1968), US sales exceeded one million, and the book was translated into many languages, including French, Italian, Dutch, German, Swedish, Spanish, and Japanese.

Global interest in America's youth rebellions increased steadily throughout the 1960s. But it surged in Western Europe and Japan amid the urban rebellions, Vietnam War protests, and emergence of Black Power in the late Sixties. Books often served as a conduit for and symbol of these quickening currents of engagement. For example, Swedish news coverage in these years—now made available through

the film *Black Power Mixtape* (2011)—confirms how familiar such figures and their books were among Scandinavian audiences. When Stokely Carmichael, the leader of the Student Nonviolent Coordinating Committee and an internationally known proponent of Black Power, visited Stockholm in 1967, news crews recorded his speech and captured scenes of him signing scores of copies of *Black Power* (1967), the work he wrote with political scientist Charles V. Hamilton. Six years later, Swedish viewers were taken inside Harlem's National Memorial African Bookstore, where its proprietor, famed bookseller Lewis Michaux, extolled the relevance of books to contemporary Black political consciousness. As Michaux spoke, cameras panned the store's heaving shelves, bringing into focus the covers and titles of works Swedish viewers might reasonably have known. By the early 1970s, such books were familiar to reading groups and cultural societies, sold at rallies in Oakland and Frankfurt and in bookstores in New York, Paris, and Amsterdam, and absorbed by a diverse global readership.

THE POLITICS OF PROTEST PUBLISHING

If the publishing of books became part of the repertoire of Black Power in the late 1960s, not all activists aspired to be known as writers, at least not initially. Carmichael told his editor at Random House that he "never

SOUL ON ICE

**brieven en essays
van Eldridge Cleaver**

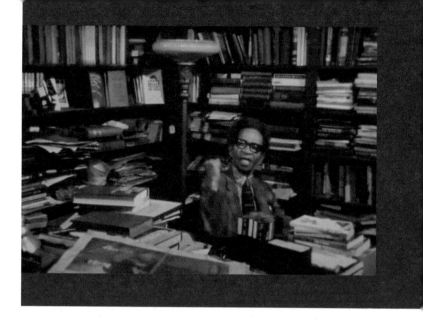

pretended to be a writer" and presented himself as "a political activist." But as his biographer Peniel Joseph reminds us, Carmichael did hope that his books would serve as a "political weapon for the period in which they are written." Imagining books as insurrectionary tools that could summon an oppositional Black consciousness—endowed with the ability to "wrestle cops into alleys," as the Black arts poet Amiri Baraka insisted new creative works must do—arose from the belief that journalism, publishing, and mass media were controlling forces in society. Radical books and cultural projects offered a means of contesting that influence.

One way in which publishing was imagined as a tool of political action by some radical groups was through the money it generated for organizational work. This was true of the Black Panther Party, which formed in Oakland, California, in 1966 and which raised considerable sums from its portfolio of cultural projects. Random House, for example, paid the Party $100,000 for the rights to publish George Jackson's second manuscript, *Blood in My Eye* (1972), anticipating that it would repeat the phenomenal success of *Soledad*

Brother (1970), which had sold half a million copies in the US in its first year. (It didn't.)

The many leftist writers, journalists, and scholars who produced sympathetic accounts of these radical groups also tended to donate the royalties they received on the books they wrote to the organizations with which they were connected. The popular historian and writer Howard Zinn gave all of the royalties from his *SNCC: The New Abolitionists* (1964), which sold impressively for two years, to that civil rights group, the Student Nonviolent Coordinating Committee, while Malcolm X's contract with Doubleday allocated royalties from his autobiography to the mosque that he established after leaving the Nation of Islam and, presciently, in the case of his death, to his widow.

The historian Philip Foner, who assembled a best-selling anthology of documents about the Black Panthers, generously forwarded royalty checks to the Panthers' attorney. Foner's *The Black Panthers Speak* (1970) became a staple of US campus groups and, given the Black Panther Party's international fame, spawned three foreign-language editions. Such translations seldom generated

much further revenue, though they did make the party's key documents widely accessible. "No one ever . . . makes money on these sort of negotiations," a US editor told Foner when he was contacted by a Hungarian publisher. But granting translations of the "book will [make it] . . . accessible to readers behind the Iron Curtain." It was one way the global New Left cut through this period's divisions of East and West.

The many groups of European supporters who formed around American Black Power groups also looked to publishing as a means of generating funds for their US allies. A modest run of pamphlets that the activist Karl-Dietrich Wolff, former leader of the Sozialistische Deutsche Studentenbund, produced on behalf of the West German Solidaritätskomitee für die Black Panther Partei made clear that "earnings from the sale of the pamphlet will go to the 'Black Panther Party,'" with readers encouraged to make further financial contributions if they could.

Still, many of the books that US Black Power activists wrote in these years were produced by the most prestigious presses. Random House, Doubleday, and W.W. Norton were behind many of the major works—a pattern that testifies to Theodor Adorno's claim that in the US "all cultural products, even the non-conformist ones, are incorporated into the mechanism of distribution of large-scale capital." These publishers positioned themselves as enthusiastic supporters of the country's new radicals, becoming skilled at demonstrating the depth of that commitment—and at defusing charges that they were selling activists' ideas back to them.

In several ways, US publishers also shaped the circulation of books about Black Power beyond the US. Alongside negotiating the sale of foreign rights, they also determined the flow of texts into international markets—particularly as they saw that much of the global audience for American radicalism lay with university students, and therefore with a foreign-language

THE BLACK PANTHERS SPEAK

**The Manifesto of the Party:
the first complete documentary
record of the Panthers' program**

Philip S. Foner, editor

audience with a command of English. The Dutch publisher Rob van Gennep told Random House editors that "the Dutch read a tremendous amount of English and American paperbacks in the original edition," and as such his intended translation of Carmichael and Hamilton's *Black Power* would "compete heavily with the American pocketbook editions" of the same. As we will see, US publishers also exerted some influence over how many of these books were designed and styled for European audiences.

CAMPUS CONNECTIONS

If US and European publishers identified a student-activist market of consumers for many of the radical and activist texts they produced, we should remain alert to the work that many students and campus groups did in producing these works in the first place. Across the US, a thickening web of social and political threads bound campuses and communities, bringing students, scholars, local residents, and activists together around a shared set of activities, including the co-production of scores of cultural and textual projects. These books not only fired the imaginations of activists around the world, but their production also deepened collaborations between them.

The formation of the Black Panther Party exemplified these intersections. The historian Donna Murch has observed that the

party grew out of a dialogue between "study group[s] and street rallies," and the party's energetic publishing campaign supports her claim. It was New Left journalist-activist Robert Scheer who assembled Cleaver's *Post-Prison Writings* (1969), and freelance writer and law student Art Goldberg who turned a series of interviews with party cofounder Bobby Seale into the compelling narrative of *Seize the Time* (1970).

Scholars supportive of Black Power groups also prioritized the campus audience as a market for such works. Philip Foner, who taught at Lincoln University in Pennsylvania, ad-

vised party activists that their books would sell in large numbers at "stores on the college campuses" and would likely "be used in Black Studies Departments all over the country." Several Black Power books were therefore designed to make them seem familiar to an academic audience. Charles Hamilton insisted that *Black Power* include a bibliography of "sources we *actually* used," because this "keeps us legitimate."

Weaving their way through this social tapestry were scores of foreign students, many from Western Europe working on advanced degrees. They were brought by scholarships to study at America's preeminent institutions of learning or propelled by personal intrigue to explore the experimental cultures on offer in the country's burgeoning countercultural centers. In classrooms, residence halls, and assorted student groups and political organizations, foreign students mingled and organized with their American peers, frequently expanding US networks upon their return home.

ELDRIDGE CLEAVER

ZUR KLASSEN-ANALYSE DER BLACK PANTHER PARTEI

ELDRIDGE CLEAVER

musta pantteri

The constant cycling of diverse bodies of students and activists through these scenes was especially intense in California's Bay Area, nowhere more so than at the University of California, Berkeley. This was particularly the case in that institution's sociology department, the nation's best, where students and scholars began to imagine a field that engaged with the pressing social issues of the moment. Among the international students and scholars drawn there were the Italian sociologists Alberto Martinelli and Alessandro Cavalli. The pair arrived on Harkness Fellowships in the mid-1960s and returned in the early 1970s. Like many on that campus, their attention was captured by the Black Panther Party, a magnetic presence in nearby Oakland, and fellow scholars helped make introductions.

The impulses that drew international scholars, activists, and journalists to groups like the Black Panthers varied. This was reflected in the range of publishers with which they worked to produce texts for audiences back in their native countries.

Martinelli and Cavalli chose Einaudi, Italy's premier house for political texts, to publish their anthology of documents, *Il Black Panther Party* (1971). By contrast, Karl-Dietrich Wolff printed several Panther position papers through Roter Stern, his Frankfurt imprint, which was popular among German radicals—and which reproduced several texts without permission from their US publishers.

The publication of these texts confirmed the interest that many European activists took in US Black Power's *theoretical* advances, and many picked up these books in the hope of encountering different models of liberation or discovering new critiques of oppression. Unlike in the US, though, where leftist scholars frequently served as the main coupling between activists and the cultural industries, in Europe the figure of the revolutionary intellectual was also shaped by those, such as François Maspero in Paris, Rob van Gennep in Amsterdam, and Karl-Dietrich Wolff in Frankfurt, who ran bookshops and publishing operations and who styled

BLACK POWER

étude et documents

y. loyer

E D I paris

the spaces they created—textual and physical—as critical to the exchange of knowledge and the growth of solidarity.

Because so many US Black Power books were read as part of this ongoing project of widening socialist thought to encompass figures and sites beyond Europe, several appeared in series already designed to make the conceptual arsenal of global revolution inexpensively available. Such series were often notable for the muted, uniform design and typography of their covers— the magenta jackets of Italy's Einaudi press, the Garamond font of West Germany's Edition Suhrkamp. Such minimalism stood in contrast to the punchy graphical jackets that were found on scores of European Black Power anthologies produced by smaller literary publishers—the grayscale image of the Wall of Respect on the South Side of Chicago on Paris-based Études et Documentation Internationales's *Black Power* anthology (1968), as well as the cover of *Black Power: Dokumentation* (1968), which the left-wing Berlin publisher Oberbaum assembled, with its blistering picture of America's urban rebellion. The use of contemporary photography on these projects conveyed the sense of primacy and immediacy that many European activists attached to the US Black freedom movement in these years.

STYLING BLACK POWER FOR THE GLOBAL NEW LEFT

Translations of Black Power books arrived at a pivotal moment for the European left, which was rapidly splintering in the aftermath of '68. While the lengthening shadow of US imperialism and the growing urgency of US Black Power swelled circulation of these texts everywhere after 1968, these books spread unevenly, and in varied forms, English editions overlapping with foreign translations. Predictably, their effects varied in different countries and among different groups. Those who designed these covers recognized the need to position such books as offering alternative, counter perspectives on the movement to those found in

BLACK POWER

DOKUMENTATION

STOKELY CARMICHAEL RAP BROWN MALCOLM X

DUTSCHKE
HAMMER
HOORNWEG
JACOB-BAUR
PETERMANN

KLEINE REVOLUTIONÄRE BIBLIOTHEK 2

OBERBAUMPRESSE BERLIN

hegemonic US media coverage. Examining some of their stylistic decisions and the selection of cover imagery helps to bring out exactly how they achieved this.

American publishers sought to craft an aesthetic for the Black Power books they published by activists that conveyed the immediacy, depth, and sophistication of the movement's politics. US editions of many of these works sought to avoid what one Random House editor called "ornamentation," eschewing the sensationalized, lurid symbols of mainstream caricature, such as guns, panthers, or clenched fists. When Random House published activist Angela Davis's autobiography in the US in 1974, she too insisted on being depicted in a "less predictable posture" than as a fugitive or Black militant, avoiding the "leather jacket . . . Afro hairdo, and raised fist" insignias of mainstream media caricature.

Toni Morrison, who had recently been appointed senior editor at Random House, wanted to avoid putting "gimmicky Panther symbols" on the covers of the party's books, seeking to create "a strong classic news design" instead. Her colleague at the press similarly hoped that the cover for the collective autobiography of the New York Panther 21, *Look for Me in the Whirlwind* (1971), would be "clean, stark, and powerful," with "solid color behind the title [and] subtitle for front." Such opinions were likely indebted to the style that illustrator Roy Kuhlman had popularized with his cover for Julius Lester's iconoclastic *Revolutionary Notes* (1969), which Grove Press published and which had aimed to create a "strong, vibrant jacket" using "'heavy' colors and typeface," evoking Kuhlman's earlier designs—such as for the text-dominated covers of James Peck's *Freedom Ride* (1962) and Fanon's *Wretched of the Earth* (1963).

Photography was widely used on the hardback editions of these books, especially those published in the US. As visual studies scholar Leigh Raiford has shown, photography was central to the era's social movements, and publishers were also keen to connect their projects to the news coverage that had

Am Beispiel Angela Davis

Der Kongreß in Frankfurt

Reden, Referate, Diskussionsprotokolle

INFORMATIONEN ZUR ZEIT

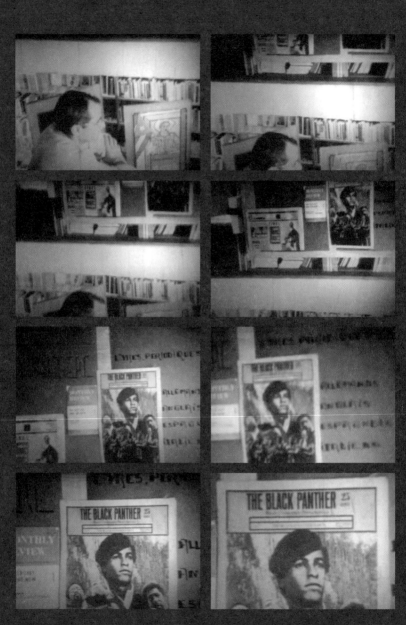

raised many of these authors to national attention. Morrison explained to the designer of Huey P. Newton's anthology *To Die for the People* (1972) that a "photo cover is my first preference," and like many editors, she worked with the images that the Black Panther Party sent to her.

US activists and organizations frequently mailed photographs they liked to their editors and sometimes offered further directions about how they wanted their books to be styled. "Carmichael wants Africa to appear on [the] cover in [the] background," Stokely's secretary told a Random House editor around the same time, "with photo with gun we sent superimposed over it!" The decision on the title for what would become Carmichael's collection of speeches and essays, *Stokely Speaks* (1971), took inspiration from *Malcolm X Speaks* (1966), with it being noted how that earlier anthology had "had great success as [a] book—*with that title.*"

One expression of the influence that large American presses had on their European counterparts was in their control of the visual materials used for the books' jackets. Random House sent the Amsterdam publisher Rob van Gennep Gordon Parks's photograph of Carmichael and Hamilton for the rear cover of the Dutch edition of *Black Power*, while De Bezige Bij's translation of *Blood in My Eye* used an image of George Jackson taken by the American photographer Ruth-Marion Baruch. Baruch and her husband, Pirkle Jones, were among a handful of photographers who worked closely with Black Power groups and whose sympathetic images were reprinted widely in the underground press and were used to raise funds, including through their later publication as a photo-essay, *The Vanguard*, that Beacon Press released in 1970.

An image that Baruch took for that assignment—of Panther leader Eldridge Cleaver in sunglasses and leather jacket—was later featured on the covers of several European editions of Cleaver's extended interview in Algiers with the journalist Lee Lockwood. Dick Bruna used a cropped version of it for his subdued green

Stokely Speaks

Black Power Back to Pan-Africanism

BY STOKELY CARMICHAEL

V-664 A VINTAGE BOOK • $1.95

George Jackson

Bloed en tranen

Door de schrijver van Soledad Brother

De Bezige Bij

Eldridge Cleaver
Lee Lockwood:
Gesprek in
Algiers

cover for the Dutch edition, *Gesprek in Algiers* (1971), and the image was the inspiration behind American designer John Alcorn's vibrant design for the Italian edition, *Conversazione con Cleaver* (1972).

Alcorn, whose career had begun at the New York design firm Push Pin Studios in the late 1950s, had moved with his family to Florence in 1971 and set about working with the publisher Rizzoli. His pen-and-ink drawing of Cleaver testified to his singular talents as an illustrator. But his merging of photograph and cartoon, his thick-lined drawing, and his use of Pop Art–esque beds of color all traced connections to other influences—including the visual style he was developing in advertisements and film posters; the imagery of Emory Douglas, the US Panthers' Minister of Culture; and the major aesthetic style of Black Power and other antiracist and anticolonial movements.

This technique of turning a well-known photograph into a print, reducing it to several flat beds of color, was conspicuously indebted to Cuban artists, such as Félix Beltrán, whose poster *Libertad para Angela Davis* (circa 1970–71) proved immediately iconic. The pattern was glimpsed in Editori Riuniti's cover for the Italian issue of Angela Davis's *La rivolta nera* (1972), which offset a familiar image of Davis on a vivid orange background, and Gallimard's covers of Jackson's *Devant mes yeux la mort* (1972) and Davis's *S'ils frappent à l'aube* (1972), which converted photographs of those activists into prints of flat color fields.

The embrace of this aesthetic by book designers was one way in which they aligned these books with the material culture of Black Power activism—making ownership of them a part of one's participation in a global movement. European publishers encouraged such connections by selecting images already known from their prior use on popular defense committee posters and other organizing documents. A photograph credited to Camilla Smith, previously used on a well-known Soledad Brother Defense Committee poster, dominated the cover of *Les frères de Soledad* (1971), for example, though

ANGELA DAVIS
LA RIVOLTA NERA

EDITORI RIUNITI

Angela Davis
S'ils frappent à l'aube...

Collection Témoins
Gallimard

George Jackson
Devant mes yeux la mort...

Collection Témoins/Gallimard

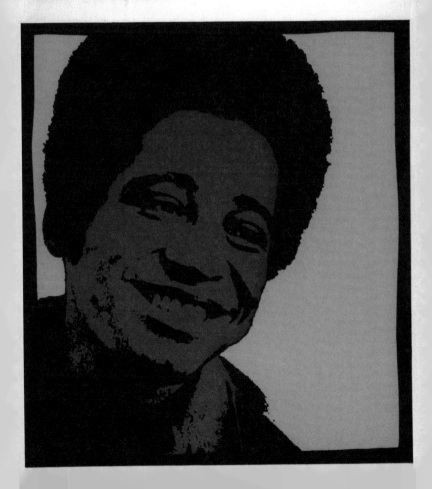

Angela Davis:

als ze 's ochtends komen...

Gallimard's decision to set that poster's hands-and-chains graphic—sometimes attributed to American artist Frank Cieciorka—in a striking yellow hue added a new urgency to this graphic.

Images celebrated for helping to mobilize support for Black Power had the added benefit of being already familiar, especially for international audiences. Indeed, it was probably a reflection of Angela Davis's unrivaled global recognition that Hungary's Kossuth press used a photograph of her—flanked by two FBI agents, following her arrest in October 1970—on the rear jacket of its abridged translation of Foner's *The Black Panthers Speak*, even though Davis was not a member of the party. (That edition's second jacket photograph of a 1968 civil rights march in Pritchard, Alabama, also had no connection with the Panthers.) In other cases, though, and especially when illustration was used, the highly stylish, "stock" markers of the US Panthers were sometimes redrawn—and Gallimard's *A l'affût* and Giammanco's *Black Power* both feature alternative renderings of Emory Douglas's leaping panther symbol with which the Oakland group had by then become internationally synonymous.

Books were a key component of US Black Power, and their publication in the US and throughout Western Europe and Asia constituted a key feature of the wider political scenery of these years. Buying, reading, and debating these texts proved to be one of the main ways in which a global New Left experienced and practiced politics in these years. The design and styling of such texts proved decisive in energizing and directing international interest in Black Power, as well as in connecting the US-based movement to other anticolonial and anti-imperialist strains of activism. Crucially, as much as these books fired the imagination of Europe's New Left—creating a shared anticolonial vernacular and layering the theoretical framework of Third Worldism—their production also frequently relied on collaborations across national boundaries. As much as they were made possible by the growing opportunities for study and travel, they also worked to deepen the intersections between students, activists, publishers, and designers. These books stand not only as accounts of this period's activism, but in many ways remarkable examples of it. ⑤

IMAGES

Page 93: Pirkle Jones, books for sale at Free Huey rally, Defremery Park, 1968.

Page 94: Roberto Giammanco, *Black Power/Potere Negro: Analisis e testimonianze* (Bari, Italy: Laterza, 1967).

Page 96: Pirkle Jones, copies of *Soul on Ice* for sale at Free Huey rally, 1968.

Page 97: Stokely Carmichael autographing books in Stockholm, 1967, *The Black Power Mixtape* (Goran Hugo Olsson, director, 2013) still.

Page 98 Top: Stokely Carmichael and Charles V. Hamilton, *Black Power: De ideologie van de zwarte macht in de Verenigde Staten* (Amsterdam: Van Gennep, 1969). Cover design by Jacques Janssen.

Page 98 Middle: Stokely Carmichael and Charles V. Hamilton, *Black Power: Die Politik der Befreiung in Amerika* (Frankfurt: Fischer Bücherei, 1969). Cover design by Hans-Jürgen Spohn.

Page 98 Bottom: Gerhard Amendt, *Black Power: Dokumente und Analysen* (Berlin: Suhrkamp, 1971).

Page 99: Eldridge Cleaver, *Soul on Ice: Brieven en essays* (Utrecht, Netherlands: A.W. Bruna, 1969). Cover photograph by Jim Ball.

Pages 100–101: Lewis Michaux's bookstore, 1973, *The Black Power Mixtape* (Goran Hugo Olsson, director, 2013) still.

Page 103: Philip Foner, *The Black Panthers Speak* (Philadelphia: Lippincott, 1970). Illustrated with cartoons by Emory Douglas.

Page 104: George Jackson, *Blood in My Eye* (New York: Random House, 1972). Cover photographs by Camilla Smith.

Page 105: George Jackson, *Soledad Brother: The Prison Letters of George Jackson* (New York: Coward-McCann, 1970). Cover photographs by Vaughn Covington.

Page 106: Eldridge Cleaver, *Zur Klassenanalyse der Black Panther Partei* (Frankfurt: Roter Stern, 1970).

Page 107: Eldridge Cleaver, *Musta Pantteri: Kirjoituksia ja puheita* (Jyväskylä, Finland: Gummerus, 1970). Cover illustration by Seppo Syrjä.

Page 109: Yves Loyer, *Black Power: Étude et documents* (Paris: Études et Documentation Internationales, 1968).

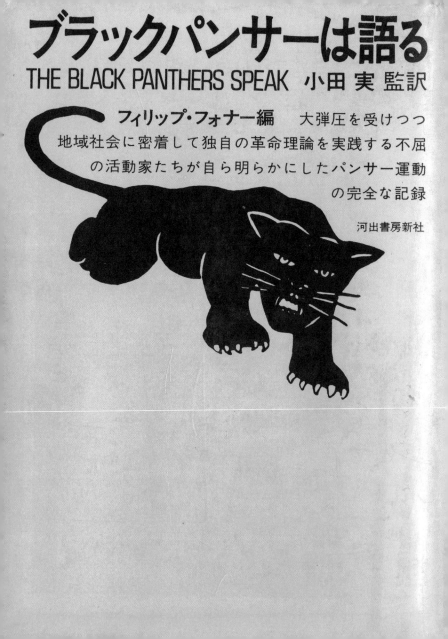

ブラックパンサーは語る
THE BLACK PANTHERS SPEAK　小田 実 監訳

フィリップ・フォナー編　大弾圧を受けつつ地域社会に密着して独自の革命理論を実践する不屈の活動家たちが自ら明らかにしたパンサー運動の完全な記録

河出書房新社

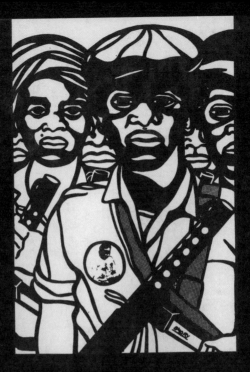

クリーヴァー、シール、ニュートン、
ヒリヤードらの論文・獄中書簡・亡命
先でのインタビューをはじめ、法廷闘
争や恐るべき弾圧の記録までも網羅。
児童無料給食計画、解放学級、人民医
療センター等の地域活動や、他の左翼
グループとの提携の実態を紹介し、第
三世界の民族解放闘争と連帯したアメ
リカ革命をめざす党活動の全貌を記録。
付＝《ジュネ、ブラックパンサーを語る》

定価1000円　　0036-057209-0961

Bobby Seale
A l'affût
Histoire du Parti des Panthères
noires et de Huey Newton

Collection Témoins/Gallimard

Page 111: R. Dutschke, M. Hammer, J. Hoornweg, R. Jacob-Baur, G.A. Petermann, eds., *Black Power: Dokumentation; Reden von Stokeley Carmichael, Rap Brown, Malcolm X . . .* (Berlin: Oberbaumverlag, 1968).

Page 113: *Am Beispiel Angela Davis: Der Kongreß in Frankfurt; Reden, Referate, Diskussionsprotokolle* (Frankfurt: Fischer Bücherei, 1972).

Page 114: Chris Marker, director, *On vous parle de Paris: Maspero, les mots ont un sens* (France, 1970).

Page 116: Stokely Carmichael, *Stokely Speaks: Black Power Back to Pan-Africanism* (New York: Random House, 1971). Cover design by Robert Cuevas.

Page 117: George Jackson, *Bloed en tranen: Door de schrijver van Soledad Brother* (Amsterdam: De Bezige Bij, 1973). Cover design by Jacques Janssen.

Page 118: Lee Lockwood and Eldridge Cleaver, *Gesprek in Algiers* (Utrecht, Netherlands: A.W. Bruna, 1971). Cover design by Dick Bruna.

Page 119: Lee Lockwood, *Conversazione con Cleaver* (Florence: Rizzoli, 1972). Cover design by John Alcorn.

Page 121: Angela Davis et al., *La rivolta nera* (Rome: Editori Riuniti, 1972). Cover design by Tito Scalbi.

Page 122: Angela Davis et al., *S'ils frappent à l'aube* (Paris: Gallimard, 1972). Cover photograph by Michelle Vignes-Gamma.

Page 123: George Jackson, *Devant mes yeux la mort* (Paris: Gallimard, 1972).

Page 124: Angela Davis et al., *Als ze's ochtends komen: Stemmen van verzet* (Amsterdam: Pegasus, 1972).

Page 127: George Jackson, *Les frères de Soledad: Lettres de prison de George Jackson* (Paris: Gallimard, 1971). Cover photograph by Camilla Smith.

Pages 128–29: Philip Foner, *Burakku Pansā wa kataru* (Tokyo: Kawade Shobō Shinsha, 1972).

Page 130: Bobby Seale, *A l'affût: Histoire du Parti des Panthères Noires et de Huey Newton* (Paris: Gallimard, 1972).

Page 169: Rob van Gennep, Nes 128 bookstore, Amsterdam. Photographer unknown. Private collection of Hedda van Gennep. Copy courtesy of Geke van der Wal.

भारत
INDIA

0

लखवीन्दर सिंह
1984 LAKHWINDER SINGH

MOST OF MY HEROES

A PROJECT BY VIJAY S. JODHA

With twenty-two official languages, 2,500 political parties, and a nine-hundred-million-strong voting population belonging to diverse religious and cultural traditions, India is a society like no other. While this diversity lends vibrancy to what is the world's biggest democracy, it also presents fault lines around language, religion, region, caste, and clan—fault lines that sometimes find expression in large-scale lawlessness and the most violent of conflicts involving minorities.

The biggest such instance in the history of independent India is undoubtedly a pogrom against India's small Sikh community back in 1984. The then Indian prime minister Indira Gandhi had been brutally gunned down by two of her own bodyguards, who belonged to the Sikh religion. What followed over the course of the next three days was large-scale violence against India's Sikh community in various parts of the country. New Delhi was the epicenter of this violence, where 2,733 Sikhs were killed, per the government figures.

Like any large-scale mob violence, a combination of political antipathy, the diffusion of responsibility within mass violence, and a snail-paced, hopelessly overwhelmed judicial system ensured that justice was largely denied to the unfortunate victims.

Most of My Heroes is a project by India-based artist Vijay S. Jodha in response to a tragedy that has yet to find closure, even after thirty-nine years. Jodha notes that even going by the conservative official figures, on average one Sikh was brutally murdered in full public view every four minutes in the heart of India's capital during those three days in 1984. That this happened in a city that boasts the biggest administrative, policing, and military infrastructure in the whole of India, and that it was watched over by the single biggest concentration of Indian and foreign media in the whole of South Asia, makes the event even more tragic.

—S. Ravi

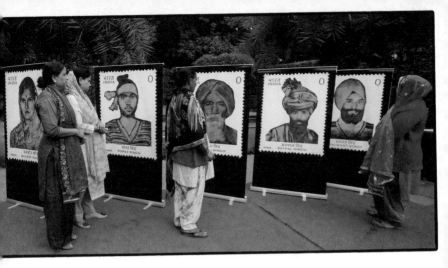

I'm ready and hyped
plus I'm amped.
Most of my heroes
don't appear on no stamps.
—Chuck D, "Fight the Power"

In India, postage stamps are the preserve of the famous or the powerful, not of the ordinary or the forgotten. Politicians as well as men and women of exceptional achievement are the standard fare. My art project subverts this idea. It features some of the men, women, and children—and even an infant—belonging to India's minority Sikh community who were murdered on the streets of Delhi thirty-nine years back.

The lack of justice, where almost all the perpetrators and enablers of this anti-Sikh pogrom have never been held to account, is a sad reflection of the zero value attached to these lost lives—hence the value denoted on these stamps. I see this as a tribute to these victims as much as to anyone anywhere in the world who has been assaulted, displaced, discriminated, or murdered on the grounds of religion, race, or any other personal attribute.

—Vijay S. Jodha

Women from Sikh community view the exhibition, 2019. Photo by Vijay S. Jodha.

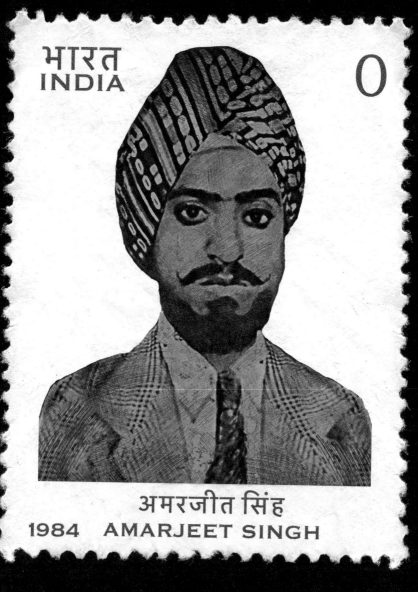

भारत
INDIA

0

अमरजीत सिंह

1984 AMARJEET SINGH

Signal08 ★ 136

भारत
INDIA

0

पलटू सिंह
PALTOO SINGH

1984

भारत
INDIA

0

जसपाल सिंह
JASPAL SINGH

1984

Signal08 ⋆ 138

भारत
INDIA

0

भाना सिंह
BHANA SINGH

1984

भारत
INDIA

0

खोटु सिंह
1984 KHOTU SINGH

Signal08 ✴ 140

भारत
INDIA

0

खोडा सिंह
KHODA SINGH

1984

भारत
INDIA

0

बलविंदर सिंह
BALVINDER SINGH

1984

Signal08 ★ 142

भारत
INDIA

0

बलवंत सिंह

1984 BALWANT SINGH

Signal08 ★ 144

भारत
INDIA

0

कृपाल सिंह
KIRPAL SINGH

1984

Signal08 ∗ 146

भारत
INDIA

0

दलजीत सिंह

1984 DALJEET SINGH

भारत
INDIA

0

तोता सिंह मसताना
1984 TOTA SINGH MÀSTANA

भारत
INDIA

0

बलबीर कौर
BALBIR KAUR

1984

Signal08 * 150

भारत
INDIA

0

गुलाब सिंह
GULAB SINGH

1984

भारत
INDIA

0

सतपाल सिंह
SATPAL SINGH

1984

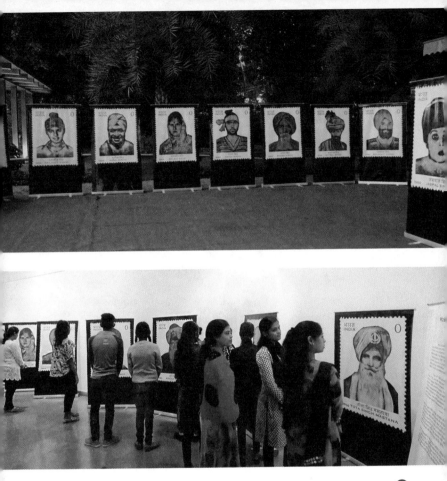

Photos by Vijay S. Jodha, 2019.

S

الحـقـوق تـقـاتـل
الـتي في سـبـيـل
انـا
الـتـحـر

the oppressed
and starving shall be
Victorious

OUR CODE OF MORALS IS OUR REVOLUTION

OUR CODE OF MORALS IS OUR REVOLUTION OUR CODE OF MO
OUR CODE OF MORALS IS OUR REVOLUTION OUR CODE OF MO
OUR CODE OF MORALS IS OUR REVOLUTION OUR CODE OF MO
OUR CODE OF MORALS IS OUR REVOLUTION OUR CODE OF MO
OUR CODE OF MORALS IS OUR REVOLUTION OUR CODE OF MO
OUR CODE OF MORALS IS OUR REVOLUTION OUR CODE OF MO
OUR CODE OF MORALS IS OUR REVOLUTION OUR CODE OF MO
OUR CODE OF MORALS IS OUR REVOLUTION OUR CODE OF MO

Travel Documents

The Popular Front for the Liberation of Palestine

A set of fictional airline tickets celebrating plane hijackings—this is one of the most intriguing pieces of agitprop we have ever come across. Initially shared with us by Zach Furnass, further research has shown:

1. These tickets were created in late 1970 by the Popular Front for the Liberation of Palestine Information Department, most likely from their headquarters in Syria.

2. The PFLP is a Marxist-Leninist faction of the Palestine Liberation Organization. Founded in 1967 under the leadership of George Habash, it is generally considered the left wing of the PLO and is the second largest faction after Fatah. Its main function in the late 1960s was training fedayeen, and one of its main activities in the late '60s and early '70s was hijacking planes.

3. Hijackings—generally involving few, if any, fatalities—were a common tactic of the PFLP. This was propaganda by the deed, thought to produce high-publicity spectacles to bring attention to the Palestinian struggle and Zionist occupation.

4. Patrick Argüello and three Popular Front for the Liberation of Palestine militants were tasked by PFLP leadership with hijacking El Al Flight 219 on September 6, 1970. Prior to takeoff, two of the Palestinian hijackers were unable to board the plane. This left Argüello and PFLP activist Leila Khaled to carry out the hijacking. Argüello and Khaled, strangers prior to this, posed as a married couple with Honduran passports. Thirty minutes into the flight, they drew their guns and grenades and approached the cockpit, demanding entrance. The hijacking was unsuccessful: Khaled was captured, and Argüello was shot and fatally injured.

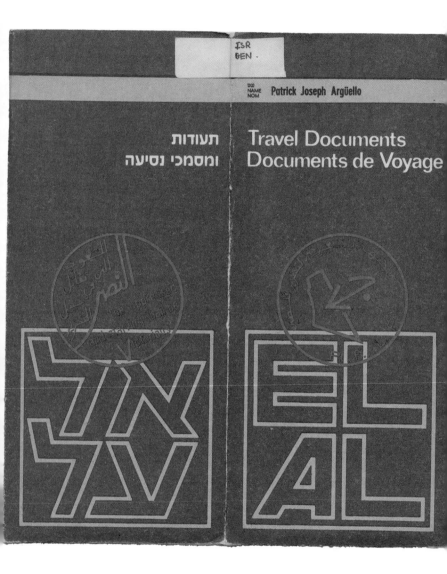

ISR
BEN.

שם
NAME Patrick Joseph Argüello
NOM

תעודות Travel Documents
ומסמכי נסיעה Documents de Voyage

אל
על

EL
AL

5. Patrick Argüello was not a member of the PFLP but was a Nicaraguan American associated with the revolutionary Sandinista movement in Nicaragua. Argüello was born in San Francisco, California, in 1943 to a Nicaraguan father and an American mother. His family moved to Nicaragua when he was three. In 1956, during nationwide reprisals by the right-wing Somoza regime, Argüello's progressive family moved back to the United States.

6. Argüello graduated from UCLA and received a Fulbright scholarship to study medicine in Chile in 1967.

7. He moved to Nicaragua shortly after to join the Sandinista National Liberation Front. Argüello was exiled from Nicaragua by the Somoza regime in August 1969 because of his activism. He went to Geneva, Switzerland, to work with other exiled Nicaraguans.

8. In early 1970, Sandinistas in Western Europe made contact with the Popular Democratic Front for the Liberation of Palestine (a 1968 split from the PFLP), and Argüello and several other Sandinistas were sent to Palestinian camps near Amman, Jordan, to receive guerrilla training from April to June 1970.

9. In the summer of 1970, Argüello and his group made contact with the Popular Front for the Liberation of Palestine. In exchange for additional guerrilla training, the PFLP asked for Nicaraguan participation in a series of hijackings.

10. The PFLP actions on September 6, 1970, were ambitious in scope, with four separate flights targeted for simultaneous hijackings.

11. During the hijacking of El Al Flight 219, Argüello reportedly threw his sole grenade down the airliner aisle, but it failed to explode, and he was hit over the head with a bottle of whiskey by a passenger after he drew his pistol. When Khaled and Argüello attempted to enter the cockpit, the pilot placed the plane into a nosedive and threw the hijackers off balance. Argüello fired his gun three to five times, wounding one flight attendant, after which he was subdued by passengers and air marshals. Argüello was then shot four times in the back.

12. Khaled had pulled the pins from her grenades but was also subdued before being able to throw them. She was beaten by security and passengers. The plane made an emergency landing at Heathrow Airport.

13. Argüello died in an ambulance en route to a hospital.

14. The other three hijackings that day were successful. Those planes were diverted to a PFLP-controlled airstrip in Jordan (the same airstrip pictured in the documents).

15. Stamped on the documents is the name Luc-Daniel Dupire, who was a Belgian communist, founder of the Belgian Palestine National Committee, and was involved in several anticolonial struggles, both in Belgium and abroad. Dupire left behind a large collection of political ephemera, so it's likely this document came from his personal archive.

16. The documents reprint correspondence between Argüello's mother and the leader of the PFLP, George Habash.

17. They also contain the PFLP's rationale for attacking El Al and other civilian airliners that served Israeli airports.

18. They are stamped with the PFLP's logo and motto, "The Oppressed and Starving Shall Be Victorious."

19. The Pan Am documents most likely refer to the hijacking of Pan Am Flight 93, hijacked the same day by Argüello and Khaled's coconspirators, who had been unable to board Argüello and Khaled's El Al plane. Pan Am Flight 93 was redirected to land in Cairo, and the hijackers blew up the plane on the tarmac following evacuation.

—Eds. ⑤

Flight No. Vol No.	פיסה מס׳
Departure time Heure de décollage	שעת המראה
Check-in time, terminal Heure d'enregistrement à l'aérogare	שעת התייצבות בבית הנתיבות
Check-in time, airport Heure d'enregistrement à l'aéroport	שעת התייצבות בנמל התעופה

LUC - DANIEL DUPIRE

Geneva, Switzerland
30 of September 1970

Mr. George Habash
Popular Front for the Liberation of Palestine

Dear Mr. Habash :

As the mother of **Patrick Joseph Argüello Ryan**, I beg you to order the British authorities to send the remains of my beloved son to Managua, Republic of Nicaragua so that he may rest alongside his fallen bretheren who also died for the liberation of their country.

I do not omit to inform you that I am proud that my son sacrificed himself for the liberation of the oppressed.

With the hope that this petition reaches your hands, I wish you future triumphs in the struggle for the liberation of the Palestinian people for whom my son gave his life.

Yours truly

Kathleen C. Argüello

אל על נתיבי אויר לישראל

EL AL ISRAEL AIRLINES

Printed in Israel 3031-2

He was educate
and in the U
fornia i
t the In
year, he

LUC - DANIEL DUPIRE

Dear Mrs. Argüello,

It is only a few days ago that I received your letter. Please pardon any delay in answering you.

I don't know whether I'll be able to express my sincere feelings. I am afraid my English will not help me here.

Madam, you should be proud of your son. We are all here very proud of him. To us he is so dear, much more dear than the comrades we are daily loosing here in our fight against Imperialism and Zionism: the enemies of mankind.

Your son, Madam, gave us a deep lesson in the real and actual bonds that tie revolutionaries all over the world together. He makes us feel that we will win our fight because all sincere and honorable men and also all revolutionary powers will be on our side.

Madam, I don't know how to express my real feelings. In our Front we have thousands of young men, fighting with zeal the same enemy who killed your son. Please be sure that all these young men are your own sons. If conditions in the near future will allow us to invite you to our camps, you will feel by yourself that this is a fact.

Please, accept my sincere and warm feelings, and also the sincere and warm feelings of all leaders and fighters of the Front.

It is an honour for me Madam, if you write me every now and then regarding any matter or problem in which I could help.

My deepest esteem and please be sure that I will do my very best.

Truly yours,

George Habash

Patrick Arguello was 27. He wa
School in Managua, Nicaragua, and
honours from the University of Cal
Scholarship to study for a year
in Santiago, Chile. For the last
in Geneva.

"Anyone who knew pat would kn
that he cared nothig for materi
goods, especially money. He was deep
concerned about the injustice in t
world, and with working to eradica
it. Even as a child in Nicaragua,
would come home without his sho
because he had given them to oth
children on the farm, whose paren
could not afford to buy them shoes

«Those of us who fulfill our obligatio
on some small point of the world map
who place at the disposal of this strug
gle whatever little we are able to give
our lives, our sacrifice, may one da
breathe our last breath in a land not ou
own, yet already ours because it i
sprinkled with our blood.»

...ed at the Christian Brothers High
...United States. He graduated with
...in Los Angeles, and won a Fulbright
...nsitute of Latin American Studies
...e had been continuing his studies

...ATRICK ARGUELLO
...YMBOL OF INTERNATIONAL
...SOLIDARITY WITH THE
PALESTINIAN STRUGGLE

«Wherever death may surprise us, it
...l be welcome, if this our battle cry,
...ds some receptive ear, if another hand
...aches out to take up our weapons,
...d other men come forward to intone
...r funeral dirge with the staccato of
...achine guns and new cries of battle
...d victory.»

Patrick Arguello was 27. He w
School in Managua, Nicaragua, an
honours from the University of Cal
Scholarship to study for a year
in Santiago, Chile. For the last
in Geneva.

"Anyone who knew pat would kr
that he cared nothig for materi
goods, especially money. He was deep
concerned about the injustice in t
world, and with working to eradica
it. Even as a child in Nicaragua,
would come home without his sho
because he had given them to oth
children on the farm, whose paren
could not afford to buy them shoes

"Both my husband and I deny th
we are ashamed of Pat. We are proud th
he felt so deeply about the injusti
done to the Palestinians that he w
prepared to die for them.

Kathleen C. Argüel

:ed at the Christian Brothers High
United States. He graduated with
in Los Angeles, and won a Fulbright
nsitute of Latin American Studies
e had been continuing his studies

ATRICK ARGUELLO
YMBOL OF INTERNATIONAL
SOLIDARITY WITH THE
PALESTINIAN STRUGGLE

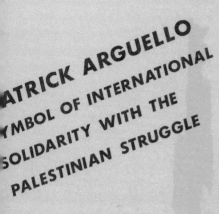

BORN TO A NICARAGUAN FATHER
AND AMERICAN MOTHER. MURDERED
BY THE ISRAELIS DURING THE ATTEMPT
TO TAKE OVER CONTROL OF AN ISRAELI
EL-AL PLANE LONDON 6/9/1970

MORALS IS OUR REVOLUTION OUR CODE OF MORALS IS OUR REVOLUTION OUR CODE OF MORALS IS OUR REVOLUTION OUR CODE OF MORALS IS OUR REVOLUTION OUR CODE OF MORALS IS OUR
MORALS IS OUR REVOLUTION OUR CODE OF MORALS IS OUR REVOLUTION OUR CODE OF MORALS IS OUR REVOLUTION OUR CODE OF MORALS IS OUR REVOLUTION OUR CODE OF MORALS IS OUR
MORALS IS OUR REVOLUTION OUR CODE OF MORALS IS OUR REVOLUTION OUR CODE OF MORALS IS OUR REVOLUTION OUR CODE OF MORALS IS OUR REVOLUTION OUR CODE OF MORALS IS OUR
MORALS IS OUR REVOLUTION OUR CODE OF MORALS IS OUR REVOLUTION OUR CODE OF MORALS IS OUR REVOLUTION OUR CODE OF MORALS IS OUR REVOLUTION OUR CODE OF MORALS IS OUR
MORALS IS OUR REVOLUTION OUR CODE OF MORALS IS OUR REVOLUTION OUR CODE OF MORALS IS OUR REVOLUTION OUR CODE OF MORALS IS OUR REVOLUTION OUR CODE OF MORALS IS OUR
MORALS IS OUR REVOLUTION OUR CODE OF MORALS IS OUR REVOLUTION OUR CODE OF MORALS IS OUR REVOLUTION OUR CODE OF MORALS IS OUR REVOLUTION OUR CODE OF MORALS IS OUR
MORALS IS OUR REVOLUTION OUR CODE OF MORALS IS OUR REVOLUTION OUR CODE OF MORALS IS OUR REVOLUTION OUR CODE OF MORALS IS OUR REVOLUTION OUR CODE OF MORALS IS OUR
MORALS IS OUR REVOLUTION OUR CODE OF MORALS IS OUR REVOLUTION OUR CODE OF MORALS IS OUR REVOLUTION OUR CODE OF MORALS IS OUR REVOLUTION OUR CODE OF MORALS IS OUR
MORALS IS OUR REVOLUTION OUR CODE OF MORALS IS OUR REVOLUTION OUR CODE OF MORALS IS OUR REVOLUTION OUR CODE OF MORALS IS OUR REVOLUTION OUR CODE OF MORALS IS OUR
MORALS IS OUR REVOLUTION OUR CODE OF MORALS IS OUR REVOLUTION OUR CODE OF MORALS IS OUR REVOLUTION OUR CODE OF MORALS IS OUR REVOLUTION OUR CODE OF MORALS IS OUR
MORALS IS OUR REVOLUTION OUR CODE OF MORALS IS OUR REVOLUTION OUR CODE OF MORALS IS OUR REVOLUTION OUR CODE OF MORALS IS OUR REVOLUTION OUR CODE OF MORALS IS OUR
MORALS IS OUR REVOLUTION OUR CODE OF MORALS IS OUR REVOLUTION OUR CODE OF MORALS IS OUR REVOLUTION OUR CODE OF MORALS IS OUR REVOLUTION OUR CODE OF MORALS IS OUR
MORALS IS OUR REVOLUTION OUR CODE OF MORALS IS OUR REVOLUTION OUR CODE OF MORALS IS OUR REVOLUTION OUR CODE OF MORALS IS OUR REVOLUTION OUR CODE OF MORALS IS OUR
MORALS IS OUR REVOLUTION OUR CODE OF MORALS IS OUR REVOLUTION OUR CODE OF MORALS IS OUR REVOLUTION OUR CODE OF MORALS IS OUR REVOLUTION OUR CODE OF MORALS IS OUR
MORALS IS OUR REVOLUTION OUR CODE OF MORALS IS OUR REVOLUTION OUR CODE OF MORALS IS OUR REVOLUTION OUR CODE OF MORALS IS OUR REVOLUTION OUR CODE OF MORALS IS OUR
MORALS IS OUR REVOLUTION OUR CODE OF MORALS IS OUR REVOLUTION OUR CODE OF MORALS IS OUR REVOLUTION OUR CODE OF MORALS IS OUR REVOLUTION OUR CODE OF MORALS IS OUR
MORALS IS OUR REVOLUTION OUR CODE OF MORALS IS OUR REVOLUTION OUR CODE OF MORALS IS OUR REVOLUTION OUR CODE OF MORALS IS OUR REVOLUTION OUR CODE OF MORALS IS OUR

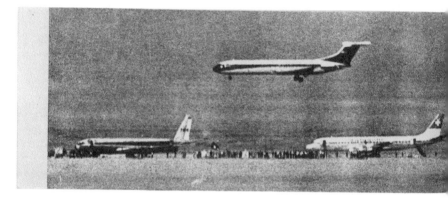

MORALS IS OUR REVOLUTION OUR CODE OF MORALS IS OUR REVOLUTION

tacked and destroyed. Tourists should understand that Israel is no sight-seeing place to go to, immigrants should know that Israel is no safe place to settle in, and mercenaries should realise, from the very beginning, that they are fighting a lost battle, because the Palestinians will track them down, on their way to or out there in occupied palestine.

In this fight, EL AL is not the only target. All Zionist and Israeli institutions any where and at any time, are legitimate targets for us to attack.

The PFLP refuses to consider any one person, institution or government as third party, if this person, happens to be visiting «Israel», or calling on any of its embassies, consulates or offices, buying from a Zionist establishment or giving aid and assistance to the usurper settler state in Palestine.

In our strategy, we have clearly stated that our fight is not limited to Palestinians alone. Revolutionaries of various parts of the world find in our struggle a role to play. Theirs is a participation which we welcome with militant and revolutionary feelings.

With this very same spirit we welcomed the efforts of comrade Patrick Joseph Argüello Ryan who, with a member of the P F L P attempted to take over control of an EL AL plane on 6 September 1970. Patrick Argüello, who was born to a Nicaraguan father and an American mother, willingly fought and heroically died for the liberty and freedom of the Palestinian people. Patrick who was cold-bloodedly murdered by the Israeli assasins on board the EL AL plane, over British air space paid his life to give unto the oppressed the real meaing of sacrifice.

Patrick Joseph Argüello Ryan has proved beyond any doubt that he is a revolutionary internationalist. He has committed himself to the Revolution of the oppressed people and fought along side with them.

INFORMATION DEPARTMENT P. F. L. P.

FOR ISSUING OFFICE USE ONLY			**אל על נתיבי אויר לישראל בעמ** "ע קונצ"ל	PASSENGER TICKET AND BAGGAGE CHECK			114		
FROM/TO	CARRIER	FARE CALCULATION	ISSUED BY	**EL AL ISRAEL AIRLINES LTD** SUBJECT TO CONDITIONS OF CONTRACT ON PAGES 2,3	PASSENGER COUPON		AIRLINE FORM SERIAL NUMBER		C.O.

EL AL ISRAEL AIRLINES LTD

FOR ISSUING OFFICE USE ONLY		COMPLETE ROUTING. THIS TICKET AND		CONJUNCTION TICKET(S)			DATE AND PLACE OF ISSUE OF THIS TICKET		

ORIGIN NICARAGUA
DESTINATION PALESTINE
ISSUED IN EXCHANGE FOR
DATE AND PLACE OF ORIGINAL ISSUE 6/9/1970 JAFFA

ENDORSEMENTS
VALID ON PFLP AIRLINES ONLY

BAGGAGE					NOT GOOD FOR PASSAGE				AGENT			
FREE ALLOW	Checked Pcs. WT	Unck'd WT	VALID UNTIL	FROM		FARE CLASS/BASIS	VIA CARRIER	Flight Number	DATE	TIME	Res Status	
	1 9 1			TEL AVIV		Y	EL AL		6/9	800	OK	
				AMSTERDAM		Y	FRONT 707		6/9	1230	OK	
				REVOLUTION			V O I D					

FARE GRATIS
EQUIV. AMT PAID VOID
TAX £L 1
TOTAL £L 1

NAME OF PASSENGER PATRICK JOSEPH ARGUELLO

FORM OF PAYMENT CASH

If the passenger's journey involves an ultimate destination or stop in a country other than the country of departure, the Warsaw Convention may be applicable and the Convention governs and in most cases limits the liability of carriers for death or personal injury and in respect of loss of or damage to baggage

ADVICE TO INTERNATIONAL PASSENGERS

On 23 July 1968, An Israeli EL AL Boeing 707 was taken control of by three commandos of the Popular Front for the liberation of Palestine shortly after its take off from Rome on its way to Lydda Airport in occupied Palestine, changing its course land in Algiers.

On 26 December, 1968, another EL AL Boeing was attacked on the ground at Athens airport by two commandos of the PFLP. similar attack on another EL AL Boeing, by four commandos of the PFLP, took place at Klotten Airport in Zurich on 18 Febrary 69. One of the commandos who took part in the attack, was cold- bloodedly murdered by an «Israeli security officer» while he as in the hands of the Swiss police after having been disarmed along with his three other comrades.

These three actions by the PFLP against EL AL Airliners, came out of a conviction, which has been proved on a number of ccasions, that these so-called «civil» aircrafts were continuously being used for military purposes, and that EL AL pilots serve as servists in the Israeli Airforce.

For years, this airforce acted as an instrument of death against our people — men, women, children and aged. The napalm, dropped on our innocent children and workers, came at the hands of these pilots and their stock.

This is the main reason why we view the so-called « civilian » planes as military targets, and therefore elegible to attack.

A second reason stems from our understanding of the enemy and the strategy that should be followed to bring about its defeat.

Through EL AL, Israel is importing thousands of tourists, immigrants, and mercenaries whose efforts or money, is being used further Zionist aims in usurpation of our land and rights. This important link of Israel with the Imperialist world must be at—

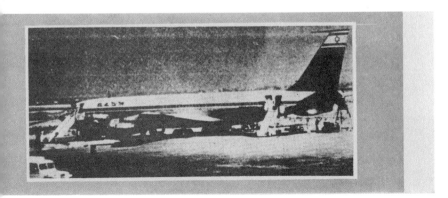

PASSENGER TICKET & BAGGAGE CHECK כרטיס נוסע וכרטיס כבודה

ISSUED BY EL AL
ISRAEL AIRLINES LIMITED
Lod Airport, Israel
Member of International
Air Transport Association

Each passenger should
carefully examine this
ticket, particularly the
Conditions of Contract
on pages 2-5.

הוצא ע"י אל על
נתיבי אויר לישראל בע"מ
נמל תעופה לוד. ישראל
חבר האיגוד הבינלאומי
לתובלה אוירית

על כל נוסע לעיין
בקפדנות בכרטיס זה,
וביחוד בתנאי החוזה
בעמודים 5-2.

אל
על

THREE FLIGHT

PASSENGER TICKET

PAN AM

PAN AMERICAN
WORLD'S MOST E
MEMBER OF INTERNATIONA

EACH PASSENGER SHOULD CAREFULLY EXAMINE T
CARRIER RESERVES THE RIGHT TO REFUS
TICKET IN VIOLATION OF APPLICABLE LAV

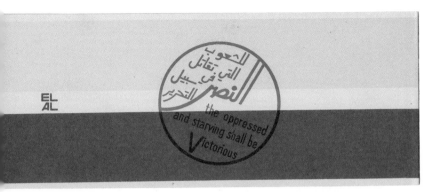

EL
AL

للشعوب
التي تقاتل في سبيل **نصر** التحرير

the oppressed
and starving shall be
Victorious

BAGGAGE CHECK

ERICAN

Y

AIRWAYS INC.

ENCED AIRLINE

TRANSPORT ASSOCIATION

PARTICULARLY THE CONDITIONS ON PAGE 2

TO ANY PERSON WHO HAS ACQUIRED A

RRIER'S TARIFFS, RULES OR REGULATIONS.

CONTRIBUTORS

Alec Dunn is an illustrator, a printer, and a nurse living in Portland, Oregon. He is a member of the Justseeds Artists' Cooperative.

Andrew Fearnley is a historian at the University of Manchester, with interests in the history of racial thought, African American intellectual history, urban studies, and the histories of leisure and work. Much of his research and writing deals with the concept of race and the history of racial thought in the twentieth century.

Vijay S. Jodha is a writer, photographer, and filmmaker based in Gurgaon, India. His projects have been showcased in galleries and museums and at film festivals worldwide. His films have been broadcast on 75 channels in 195 countries including on BBC, CNN, and Discovery.

Josh MacPhee is one of the founders of Interference Archive, organizes the Celebrate People's History Poster Series, and is a member of the Justseeds Artists' Cooperative.

S. Ravi writes on science, evolution, and wildlife as well as trends in culture, history, and art and stories of human interest. He is the cultural editor at *India Narrative* (indianarrative.com).

Dread Scott is a visual artist whose work is exhibited across the US and internationally. In 2019, he presented *Slave Rebellion Reenactment*, a community-engaged project that reenacted the largest rebellion of enslaved people in US history. The project was featured in *Vanity Fair*, the *New York Times*, and CNN and highlighted by artnet.com as one of the most important artworks of the decade.

UPDATES

A brief and incomplete accounting of publications and exhibitions that have followed related features from *Signal*'s back issues:

Autonomy: The Cover Designs of Anarchy, 1961–1970 is a book on the design work of Rufus Segar. It includes our interview with Segar from *Signal:01* and much more (Hyphen Press, 2013).

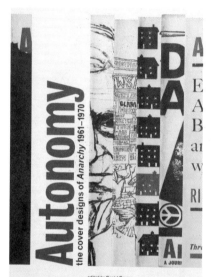

Dea Trier Mørch, a key member of the Røde Mor collective (featured in *Signal:02*), received a much-deserved retrospective of her work at Denmark's Louisiana Museum of Modern Art in 2019. This exhibition also produced a large-format, hardbound catalog of her solo print work: *Dea Trier Mørch—Det grafiske værk* (Louisiana Museum Press, 2019).

Getting Up for the People: The Visual Revolution of ASAR-Oaxaca by Mike Graham de La Rosa, Suzanne M. Schadl, and ASAR-O (PM Press, 2014), covers the street art, graffiti, and prints of the Assembly of Revolutionary Artists of Oaxaca who were featured in a *Signal:02* article written by Deborah Caplow.

In 2020, the Art Institute of Chicago mounted *Malangatana:*

Mozambique Modern, a major show about the work of Mozambican artist, muralist, and activist Malangatana Ngwenya (a retrospective remembrance of Malangatana written by Judy Seidman was included in *Signal:02*). Along with the exhibit, they have digitally published several open-access scholarly articles about the life and impact of Malangatana (artic.edu).

The Medu Arts Ensemble, featured in *Signal:03* in an article by Josh MacPhee, had a large-scale retrospective in 2019 at the Art Institute of Chicago (*The People Shall Govern! Medu Art Ensemble and the Anti-Apartheid Poster, 1979–1985*). A corresponding catalog of the same title, edited by curators Antawan I. Byrd and Felicia Mings, was published in 2020.

À force d'imagination: Affiches et artéfacts du mouvement étudiant au Québec, 1958–2013 by Jean-Pierre Boyer, Jasmin Cormier, Jean Desjardins, and David Widgington was published in 2013. Widgington contributed the article on the graphic work of the 2012 Québec student strikes in *Signal:03* ("Visual Artifacts That Become Us").

Eric Triantifillou revised his contribution to *Signal:05* ("The Pyramid's Reign") about the symbology of the capitalist pyramid for the *Journal of Visual Culture* (2019, vol. 18 no. 3), "To Make What Is Vertical Horizontal: Picturing Social Domination."

Shaun Slifer expanded his history of the Appalachian Movement Press (*Signal:05*) for the University of West Virginia Press into a 256-page book titled *So Much to Be Angry About: Appalachian Movement Press and Radical DIY Publishing, 1969–1979* (2021).

Signal contributor Ryan Lee Wong ("Basement Workshop: The Genesis of New York's Asian American Resistance Culture"—*Signal:05*) published an award-winning first novel, *Which Side Are You On?* (Catapult Press, 2022).

Contributor Cathy Tedford ("Silent Agitators: Early Stickerettes from the Industrial Workers of the World"—*Signal:06*) launched the People's History Archive (peopleshistoryarchive.org), documenting "the creative and

complex ways people make use of public space" at St. Lawrence University, and is currently working on a book about international sticker culture.

Mehdi El Hajoui ("Spectacular Commodities: The Objects of the Situationist International"—*Signal:07*) delves further into Situationist history with the new publication *On the Poverty of Student Life Considered in Its Economic, Political, Psychological, Sexual, and Especially Intellectual Aspects, with a Modest Proposal for Its Remedy*, edited by Mehdi and Anna O'Meara (Common Notions, 2022).

And finally, Jordi Padró ("A Red Star and Four Red Stripes: A Fifty-Year Retrospective of the Graphics of the Catalan Independence Movement"—*Signal:07*), along with Martí Puig and Pep Garcia, has expanded his history of Catalan left independentist graphics with this thick artbook: *Difon la idea! Memòria gràfica de l'Esquerra Independentista, Adhesius 1969–2019 (Spread the Idea! A Graphic History of Independentist Left of Catalan, 1969–2019)* (Pol*len Editions, 2021). **S**

"If you are interested in the use of graphic art and communication in political struggles, don't miss the latest issue of *Signal*."

—Rick Poynor
Design Observer

"Offering these graphics to generations far beyond their original audiences, *Signal* is recommended for designers, activists, archivists, and scholars studying protest movements."

—Michael Dashkin
Library Journal

Baseline Shift Untold Stories of Women in Graphic Design History

Edited by Briar Levit

AN ENCYCLOPEDIA OF POLITICAL RECORD LABELS

SIGNAL.01

SIGNAL.03

SIGNAL.04

SIGNAL.05

SIGNAL.06

SIGNAL.07

PM

SIGNAL:07 Philadelphia Printworks • The Records of Victor Jara • Argentina's Estación Darío y Maxi • Book Arts of the Situationist International • Poster Artist and Muralist Malaquías Montoya • Belgian Expressionist Albert Daenens • Posters of the Catalan Left

SIGNAL:08 Dread Scott's *Slave Rebellion Reenactment* • *Liberation* Magazine and the Cover Art of Vera Williams • Memorializing Victims of Anti-Sikh Violence • Travel Documents of a PFLP Hijacking • The Book Designs of the Black Power Movement

PM Press is an independent, radical publisher of books and media to educate, entertain, and inspire. Founded in 2007 by a small group of people with decades of publishing, media, and organizing experience, PM Press amplifies the voices of radical authors, artists, and activists. Our aim is to deliver bold political ideas and vital stories to all walks of life and arm the dreamers to demand the impossible. We have sold millions of copies of our books, most often one at a time, face to face. We're old enough to know what we're doing and young enough to know what's at stake. Join us to create a better world.

PM PRESS
PO Box 23912
Oakland CA 94623
510-658-3906
www.pmpress.org

PM Press in Europe
europe@pmpress.org
www.pmpress.org.uk